W9-BTM-380

MADDIE
ON THINGS

MADDIE ON THINGS

A SUPER SERIOUS PROJECT ABOUT DOGS AND PHYSICS

THERON HUMPHREY

CHRONICLE BOOKS
SAN FRANCISCO

Theron Humphrey and Maddie in Dallas, Texas, August 9, 2012

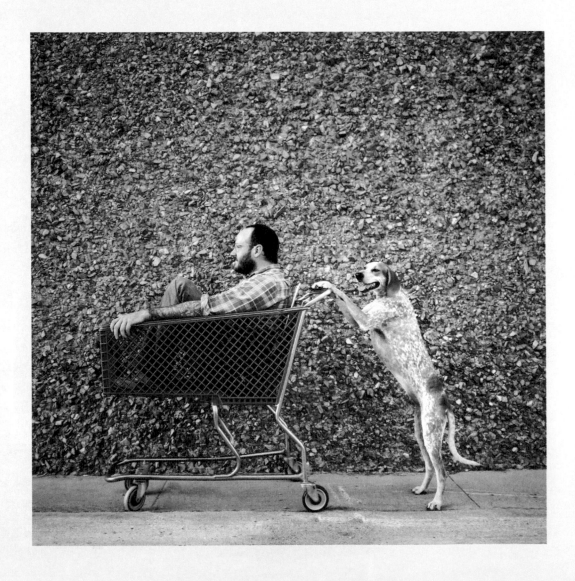

Introduction

If a man and his dog set out across America with no purpose, they'd get lost. There has to be a reason to leave a comfortable job and drive sixty-five thousand miles across the country. That comfortable job gave me a steady paycheck, an apartment, and money to buy things. The same sorts of things you might know. But I felt empty. I wasn't living a good story. I wasn't waking up creating something I'd be proud of, something beautiful.
I wanted to point at something I loved and say, "I made that." That's the story I want to tell my kids one day. What I didn't realize was how important a coonhound named Maddie would be to my adventure.

My life before Maddie was when I became an Eagle Scout, graduated high school, went to college, grad school, then found a job. Lost in all those leaps of time are the every days. The mornings I woke up and brushed my teeth and ate cereal, but you know, the other way around. There were a lot of days when I wasn't graduating from college or accepting jobs. That's what I mean.

I woke up one Idaho morning and realized that I'd never change the world. I felt small, like I didn't matter, like I wasn't living a good story. Writing those words might not seem like much. It's easy to type words. But the weight on my chest felt real. I sat up and called an old friend, Chris Barnes. By the end of our talk I decided I'd go and be the change I wanted to see in the world. Does that sound campy? I hope not, I honestly meant it. Maybe it's because that decision seems very black and white, yes or no, but what led up to that moment wasn't. It was all those mundane every days. You know, the days without celebrations or graduations.

Looking back, two things in my life brought me here. My grandfather passing and a broken heart.

In the fall of 2010 I went back to North Carolina and visited my grandfather. I had been working in a corporate photo studio for a while by then. It was the sort of job your mom would be proud to tell other moms about—that her son got a good job at a company that is traded on the

stock exchange. But I felt empty. I hadn't pointed a camera at something I loved, something I could pour my heart into, for years. I was around cameras everyday, but I was using them to sell products to people I'd never meet. Walking around my grandfather's farm that fall felt real. Looking at all the trees that had lost their leaves and stomping in the dirt that was busy resting felt real. Sitting in my grandfather's living room, with way too many logs burning on the fire to keep him warm, felt real. Recording his voice, his stories, for the last time, *was* real. And thinking about photographing products in a studio back in Idaho felt false to me.

A broken heart has always been one of the great catalysts in human history to stir a man up and create something new in his life. And I had one of those. One afternoon, a girl I loved told me, "You're the most disappointing human being ever." I'm not sure if she was right or wrong in that moment, I have long since forgiven her and myself, but if my path ever crosses yours—and I hope it does—I'll be the first to tell you I'm not always the man I should be. I'm not telling you this to be dramatic. I just want to share my story. The story of what stirred me up to do something different. And brought Maddie and I together.

Around the time that I was waking up to those Idaho mornings, feeling that heavy weight on my heart, I was also busy thinking about how burnt out on corporate life I was. Why did the world need more handbags and necklaces when my grandfather had just passed away? I was thinking about how I didn't want to be the most disappointing human ever. And right then and there I had *This Wild Idea.*

I would go into the world, traverse all 50 states in 365 days, and meet one person a day, every day. I wanted to give them a small gift. I wanted to share that experience I had when I photographed my grandfather and recorded his voice and his stories for the last time. I wanted to connect with folks and learn to love my neighbors. To celebrate all of the moments in between, the moments that aren't graduations and celebrations, all of those mundane everyday moments that really make up a life.

But the best part of this story is about the dog that came along for the ride. I figured if Steinbeck had Charley by his side on his American

travels, I needed a good dog next to me in my truck. I had no idea how much my life would change when I adopted Maddie from the animal shelter that summer. Have you ever met someone and in a minute you were old friends? It's something I can't explain, but I do know it happened. Maddie hopped in my truck, sat in the front seat, and looked at me. She fit right into my life with those big ears and fantastic white spots.

In the fall of 2011, Maddie and I said goodbye to old friends and hit the road together across America. When you're stuck behind a desk, the idea of the open road is nothing short of romantic. It's full of promises and adventure and running out of gas. I can't say anything new about the intrinsically American love of the road, but I can say that it's alive and well, and it's still beautiful. That first morning, Maddie and I sat in my old Toyota pickup trying to figure out what we had gotten ourselves into.

Some days the truck was too small, and her tail was in my face too much, but we ate together, met and photographed folks together, and slept in the back of that old pickup truck together. I even discovered Maddie's talent on that truck. One morning I figured I needed a photograph to remember how we traveled together. So I picked up Maddie and put her on the roof. She just stood there and smiled at me. Good things seem to start that way. You know, small.

Maddie taught me that I should wake up every day and be grateful. She taught me that committing to something and sticking to it is how we grow. But most of all, she taught me that standing on things, everyday objects, can be incredible. She's my best friend and I wouldn't trade our time together for anything.

Thinking back on it now, it's hard to remember my life before traveling, before Maddie. My routine life in the corporate world was the life I lived; it was the life that brought me here. We all live our own unique stories and come from unique parents. We all walk different paths and have our own history. My story has led me here, writing an intro about this wonderful dog that flipped my world.

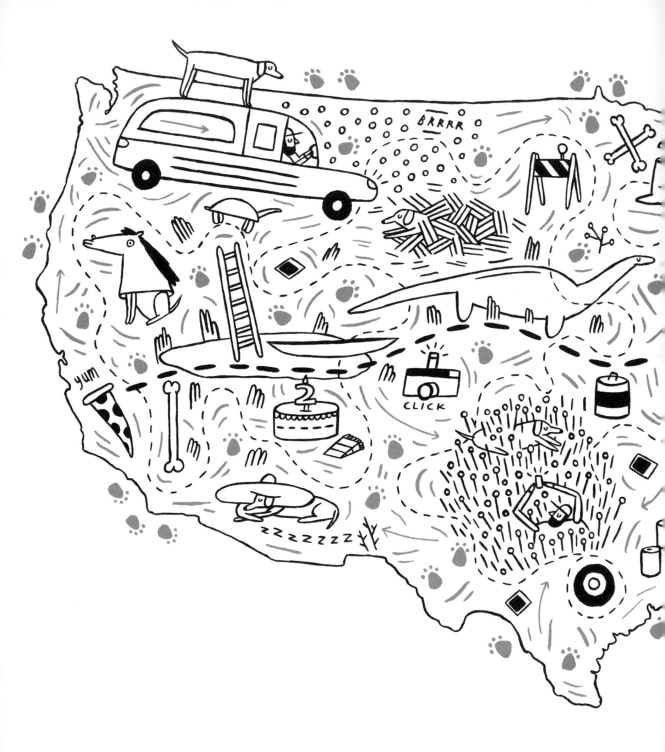

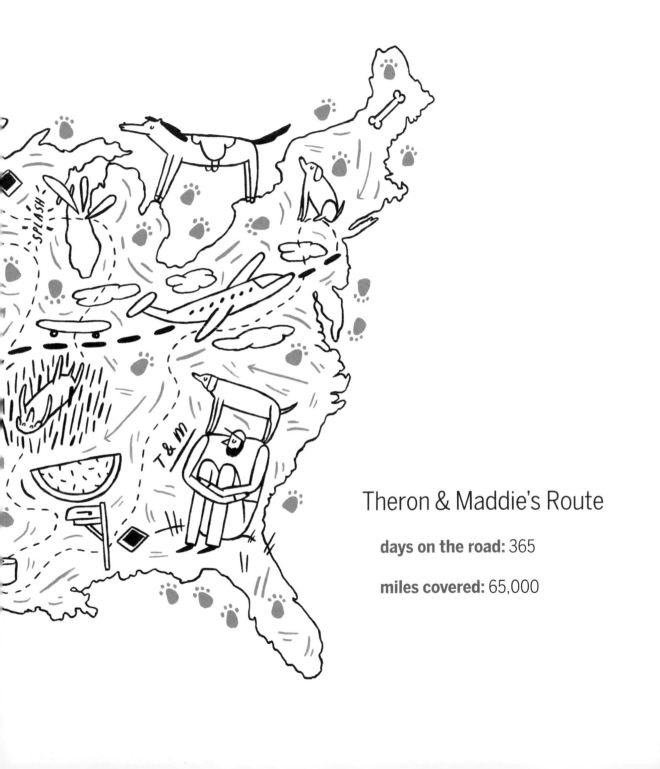

Theron & Maddie's Route

days on the road: 365

miles covered: 65,000

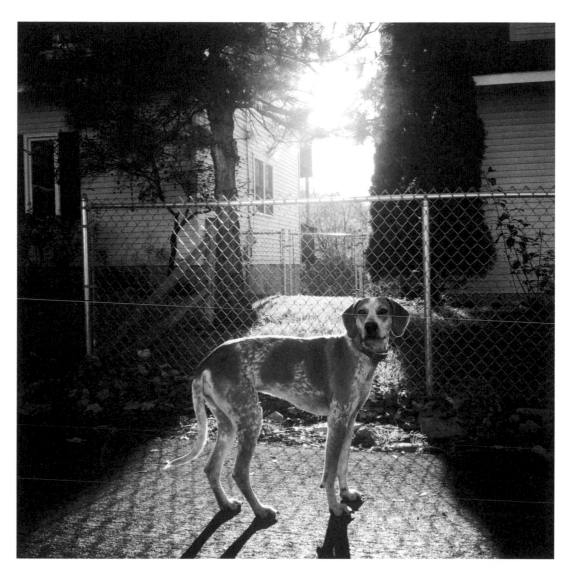

Syracuse, **New York**, November 5, 2011

This was the beginning of Maddie on things, or at least me pointing my camera her way. Looking back now I remember all the details that are outside the edges of the photo. That afternoon I was helping a friend move his motorcycle when I saw this light shining between the houses. I ran over with Maddie and put her in the middle of that light, asked her to stay, and she just looked at me.

11

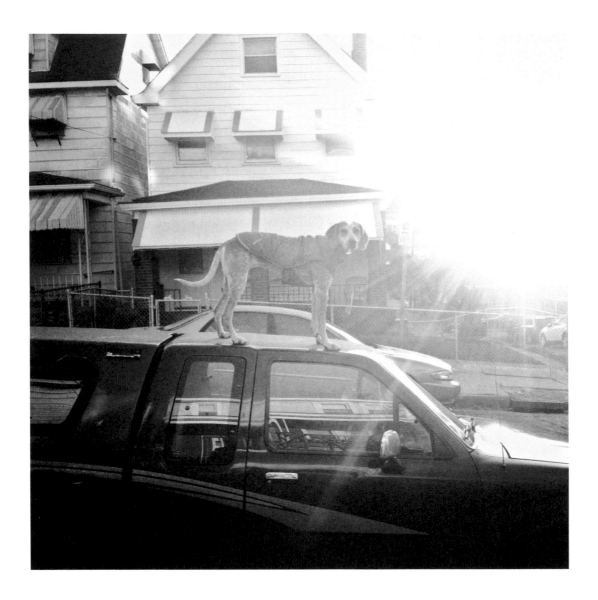

Pittsburgh, Pennsylvania, November 18, 2011

When I took this image I still hadn't thought much about putting Maddie on things. The idea and project evolved and grew organically over time. But I do remember thinking that I would want to look back and remember what my truck and companion looked like in 30 years. Sort of how old photographs of your parents' first cars feel.

12

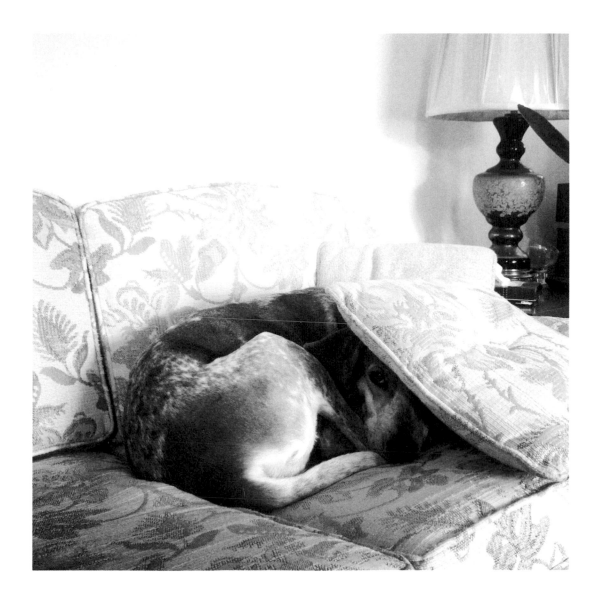

Canton, **Ohio**, November 19, 2011

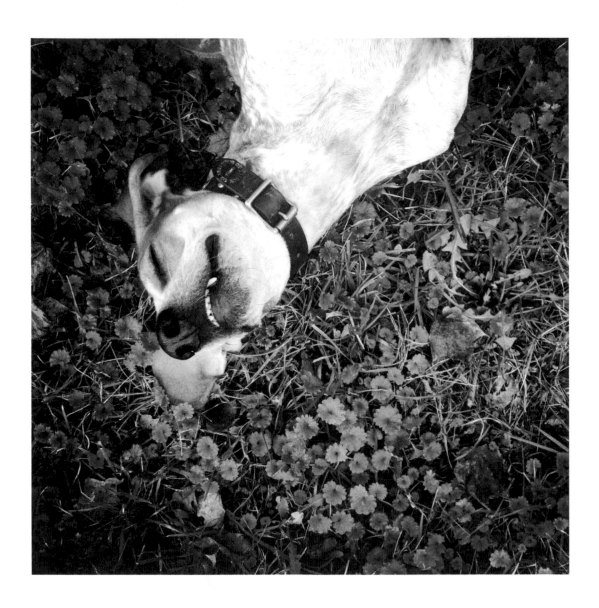

Lexington, **Kentucky**, November 29, 2011

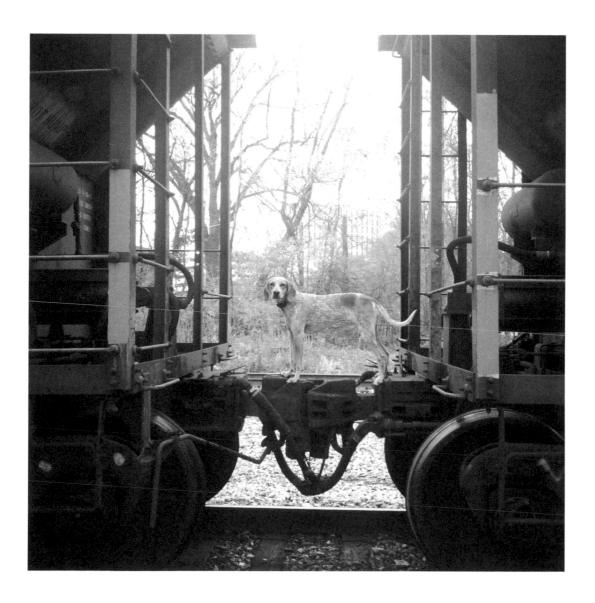

Birmingham, **Alabama**, December 15, 2011

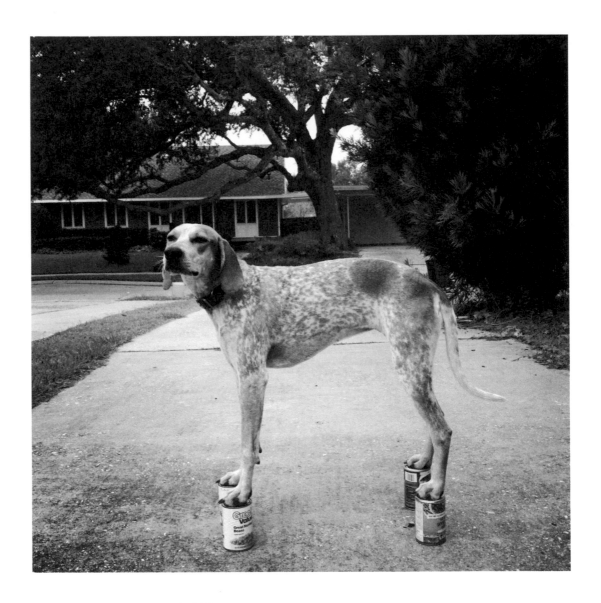

Lakeshore, Louisiana, December 21, 2011

By the time we made it down to New Orleans we had driven a few thousand miles and been traveling over four months. I woke up one morning and a friend asked if I could get Maddie to stand on four soup cans. An hour later I was putting Maddie's paws one by one on the soup. This was the start of something.

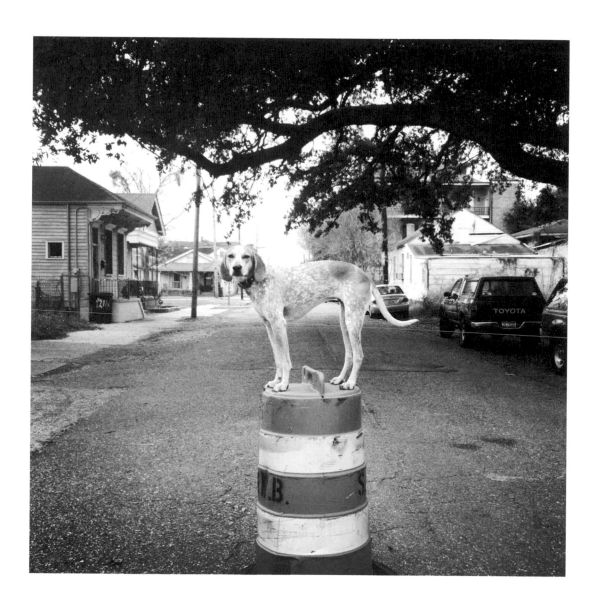

New Orleans, **Louisiana**, December 23, 2011

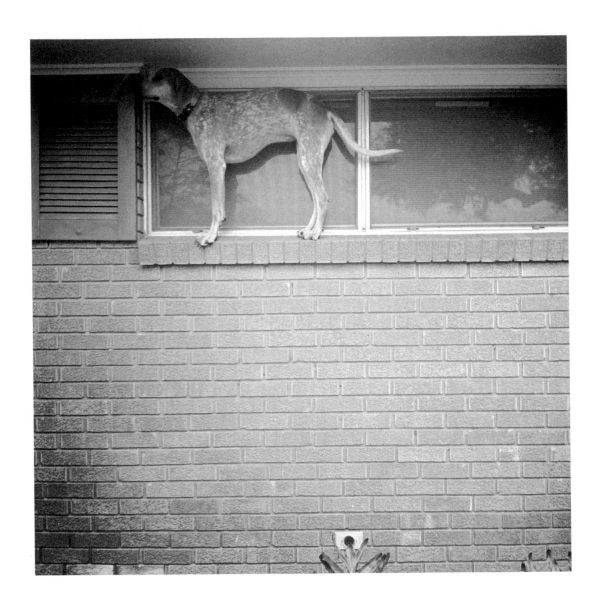

Lakeshore, **Louisiana**, December 25, 2011

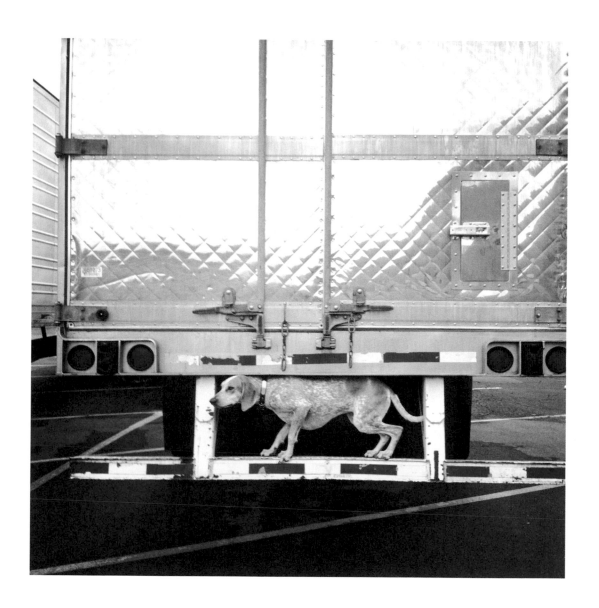

Hattiesburg, **Mississippi**, December 27, 2011

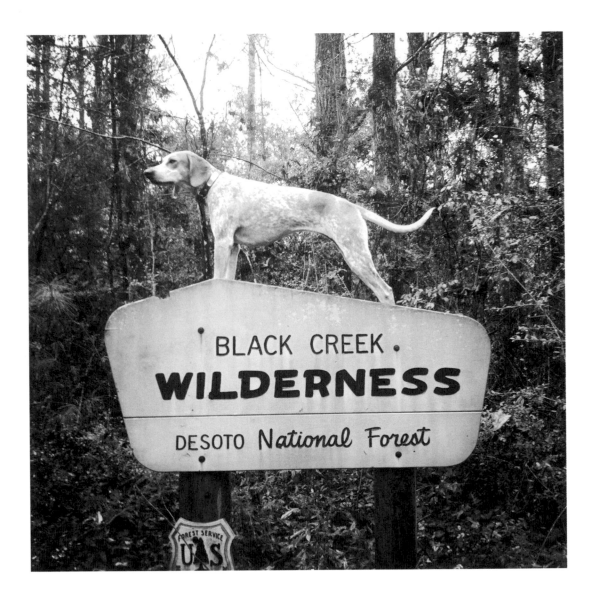

DeSoto National Forest, **Mississippi**, December 26, 2011

National Parks are my favorite spots around the country. It was such a blessing to be able to visit so many. Some days it's nice to go into the woods and be alone. It was so important to reflect back and look ahead to the miles we had left. I'll always remember driving down the fire roads with Maddie and finding a great camping spot. Good memories.

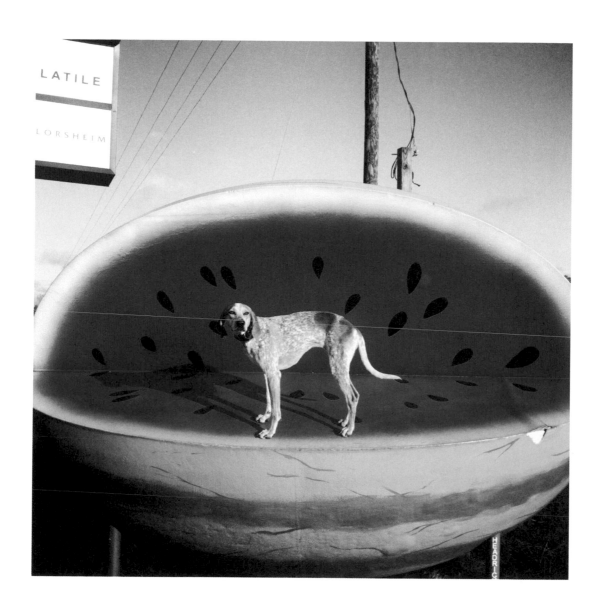

Hattiesburg, Mississippi, December 27, 2011
The adventure is always on the smaller roads, discovering all the Americana. I passed by this
giant watermelon on Highway 11 and had to turn around.

21

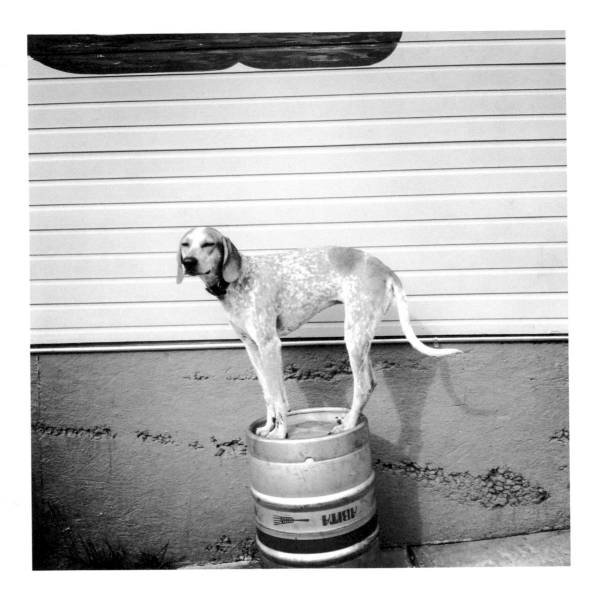

Jackson, **Mississippi**, December 28, 2011

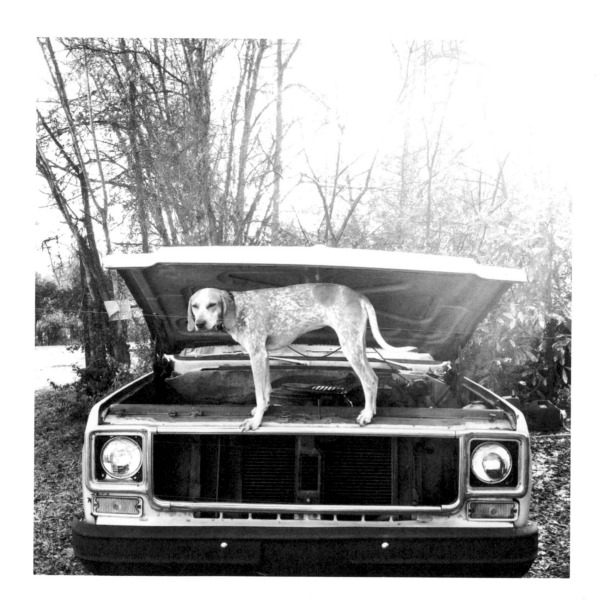

Jackson, **Mississippi**, December 29, 2011

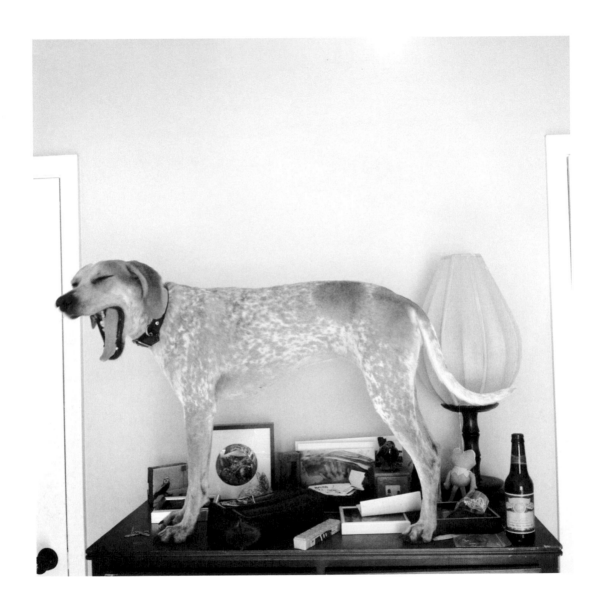

Jackson, **Mississippi**, December 30, 2011

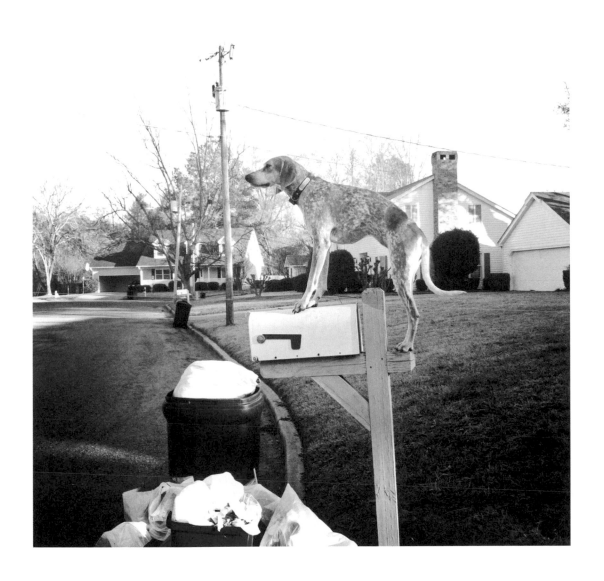

Jackson, **Mississippi**, January 5, 2012

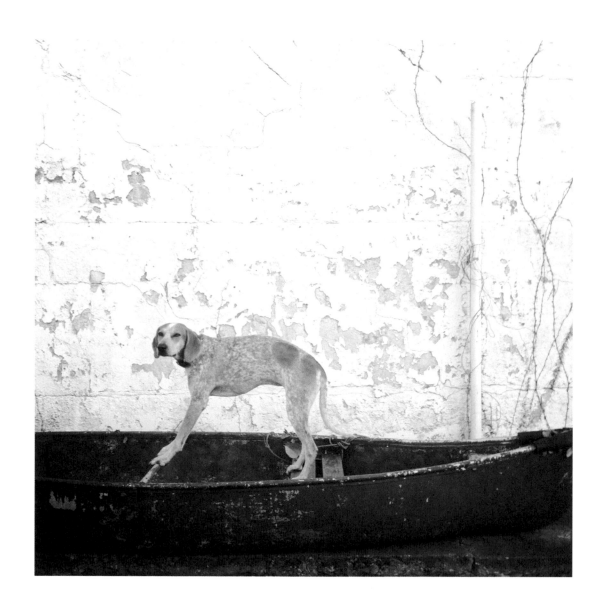

Jackson, **Mississippi**, January 3, 2012

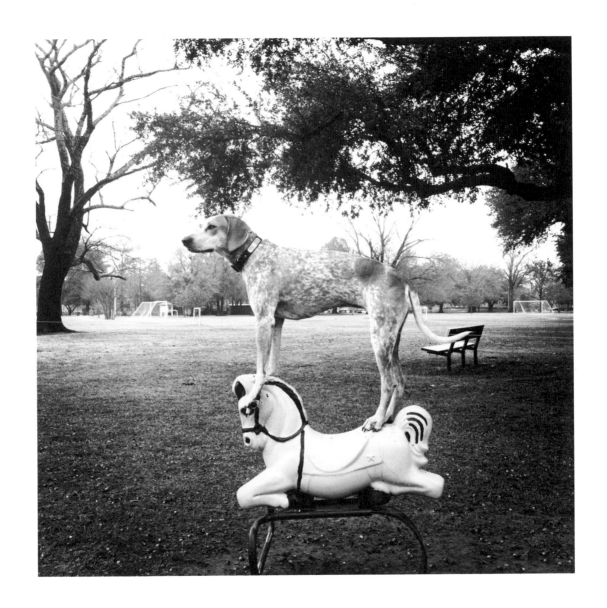

Monroe, **Arkansas**, January 10, 2012

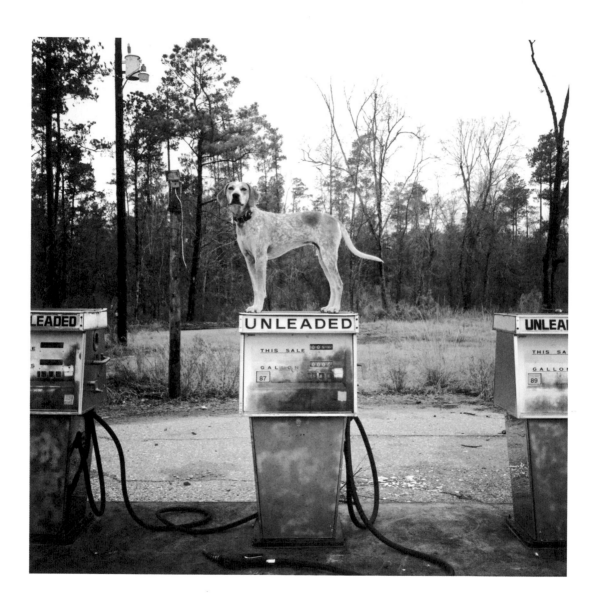

Sparkman, **Arkansas**, January 11, 2012

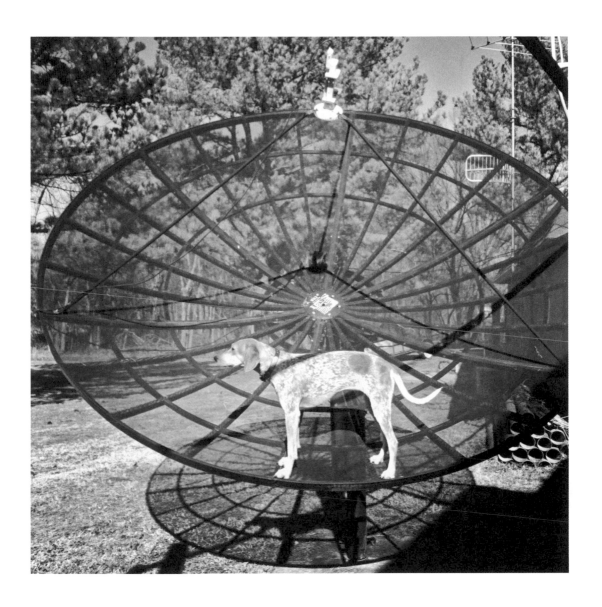

Siloam Springs, **Arkansas**, January 17, 2012

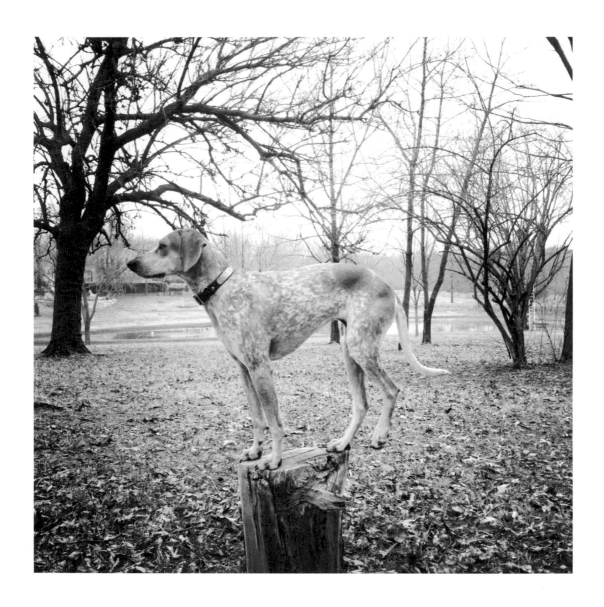

Lee's Summit, Missouri, January 22, 2012

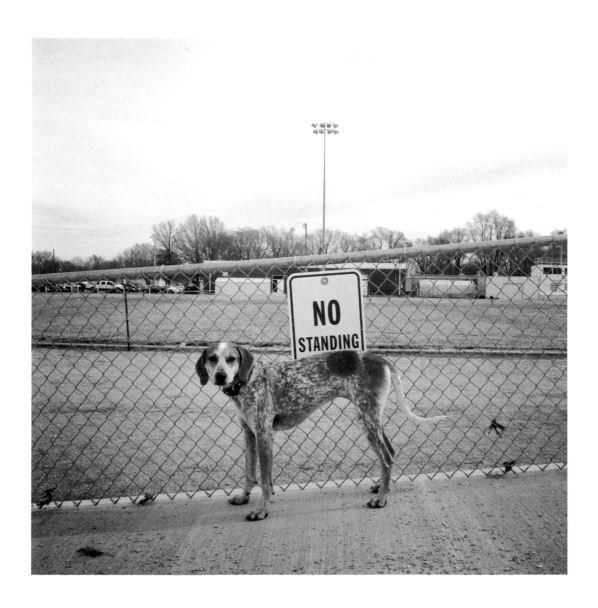

Orrick, **Missouri**, January 24, 2012

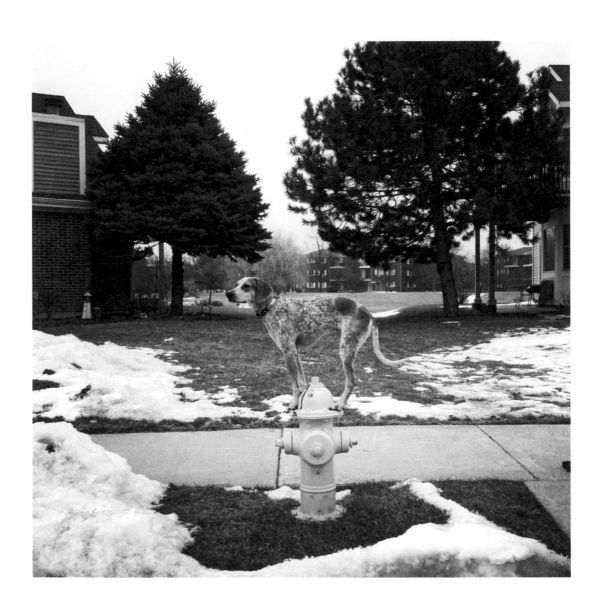

Carol Stream, Illinois, January 26, 2012

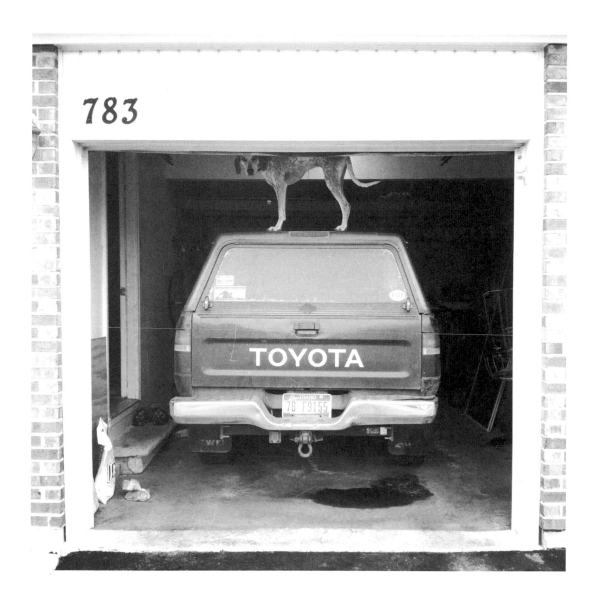

Carol Stream, Illinois, February 1, 2012

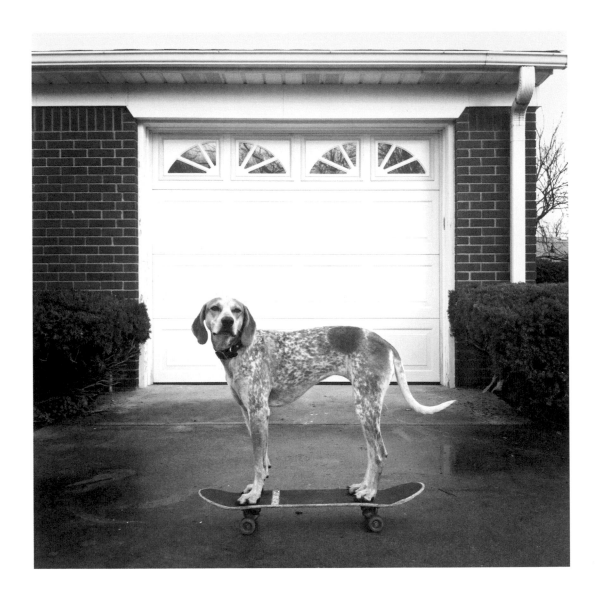

Columbus, Indiana, February 5, 2012

34

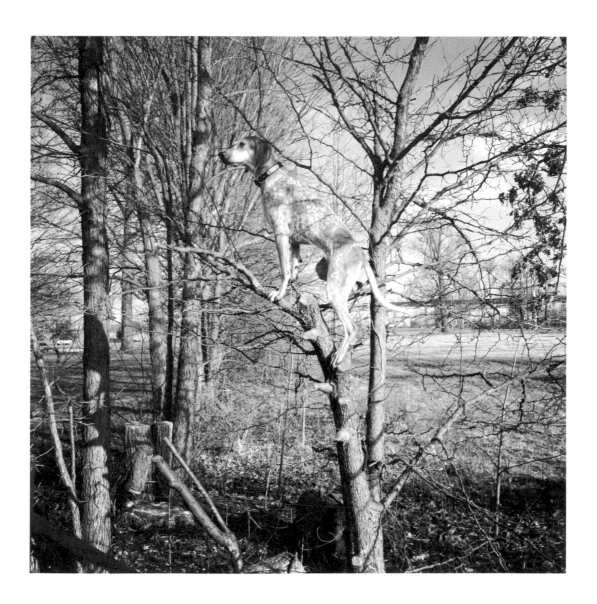

Fort Wayne, Indiana, February 6, 2012

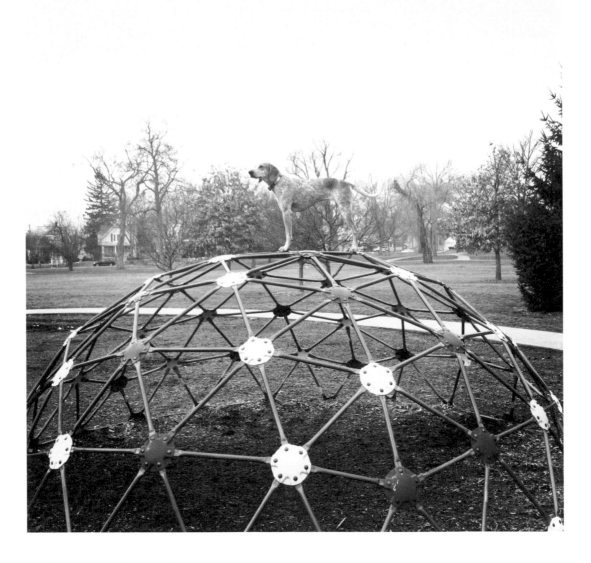

Fort Wayne, Indiana, February 7, 2012
Over time Maddie became a wonderful stand-in for telling the story of what I love in life.
I might be simple but I have wonderful memories of climbing jungle gyms growing up.
You don't see this style of jungle gym as often in newer parks. But there are still plenty
out there across the country.

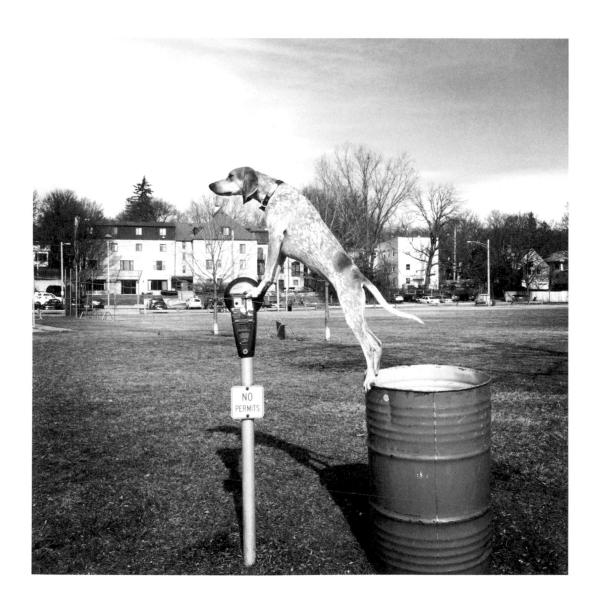

Lansing, **Michigan**, February 8, 2012

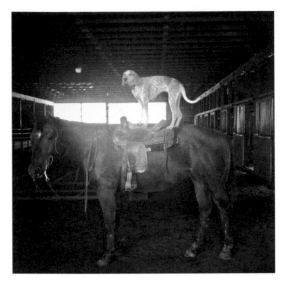

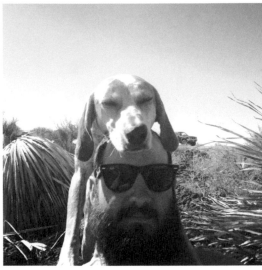

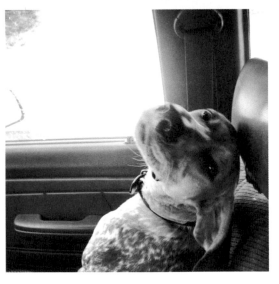

Grand Rapids, Michigan

Milwaukee, Wisconsin

Glencoe, New Mexico

Hiawatha National Forest, Michigan

38

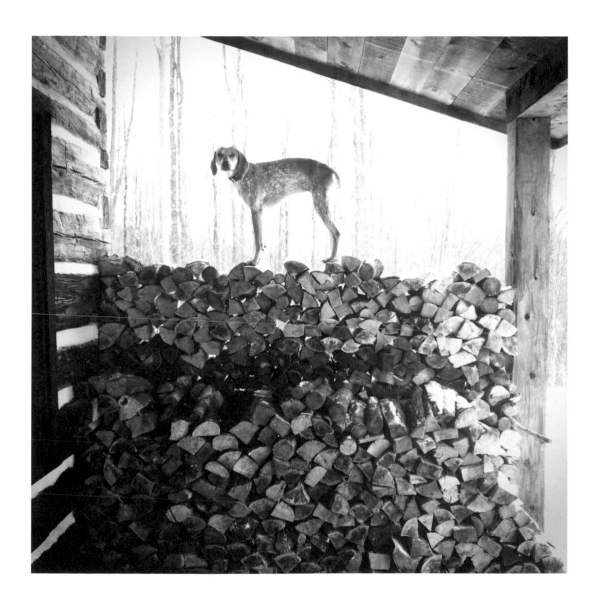

Bentley, Michigan, February 11, 2012

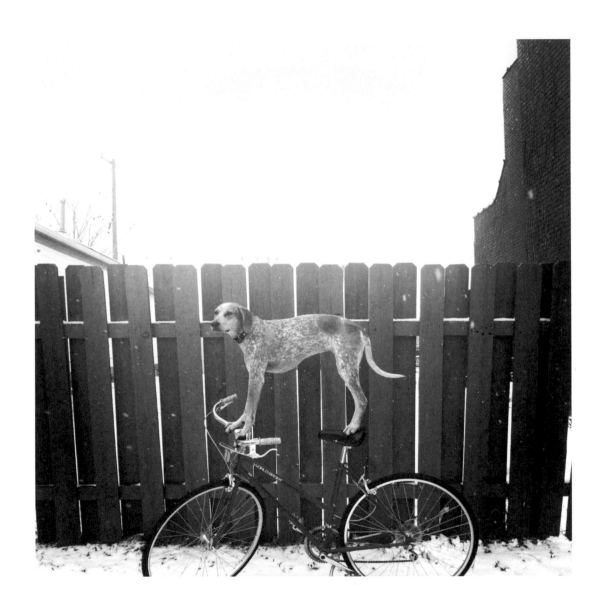

Detroit, **Michigan**, February 14, 2012
The fun in creating these images is that they always came together quickly. I just responded
to what was around me. My friend had this red bicycle in his house and after he left for work,
I wondered if Maddie could stand on it. She could!

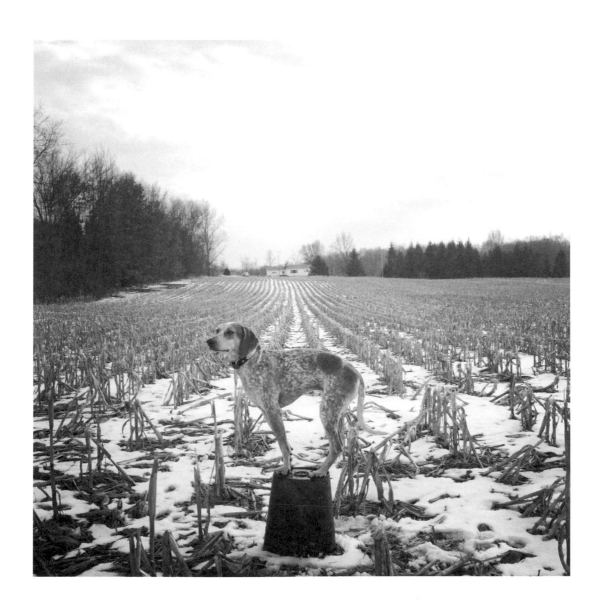

Parma, **Michigan**, February 15, 2012

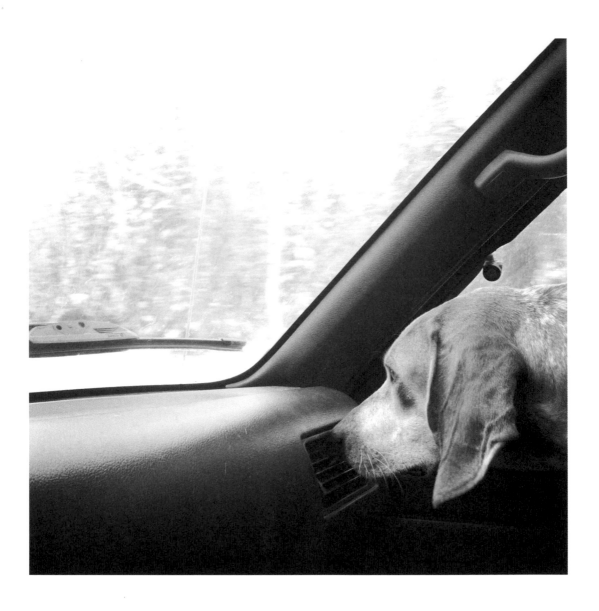

Roscommon Township, **Michigan**, February 16, 2012

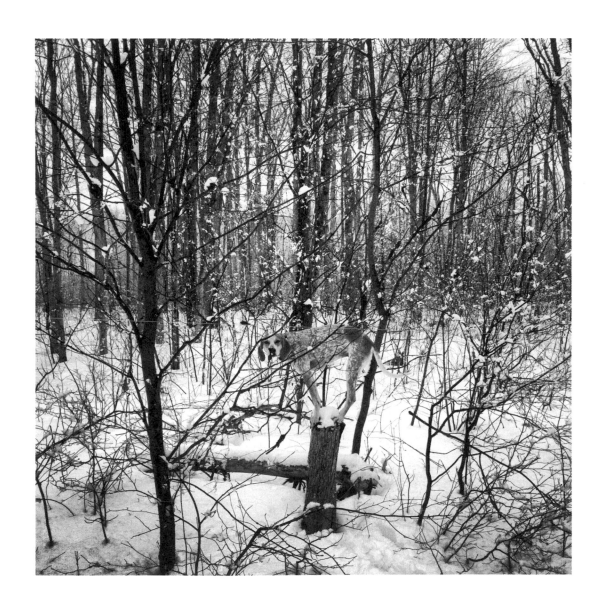

Huron National Forest, **Michigan**, February 16, 2012

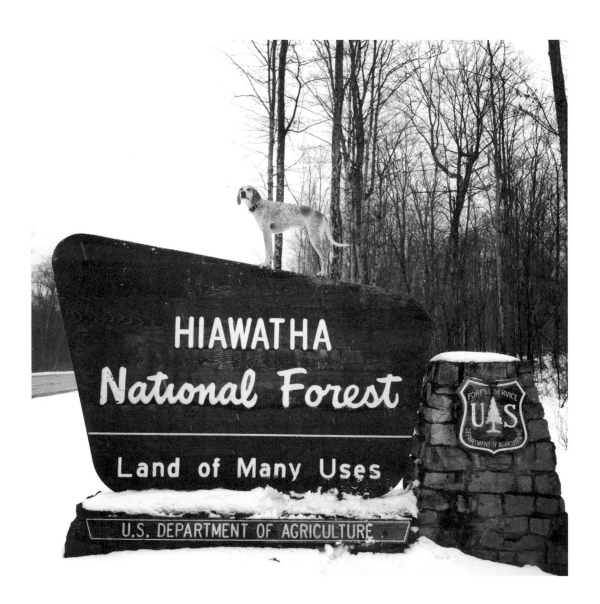

Hiawatha National Forest, **Michigan**, February 16, 2012

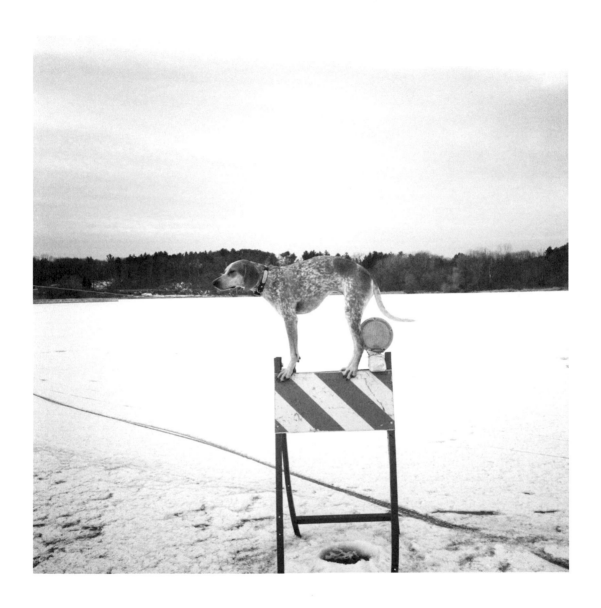

Minneapolis, Minnesota, February 20, 2012

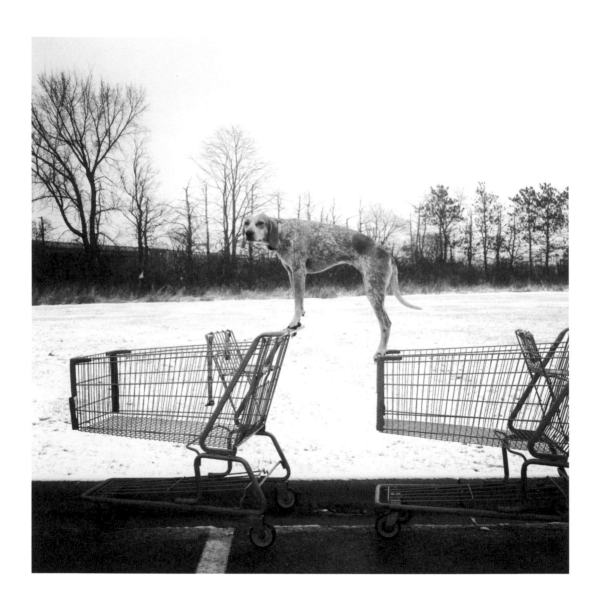

Tomah, **Wisconsin,** February 21, 2012

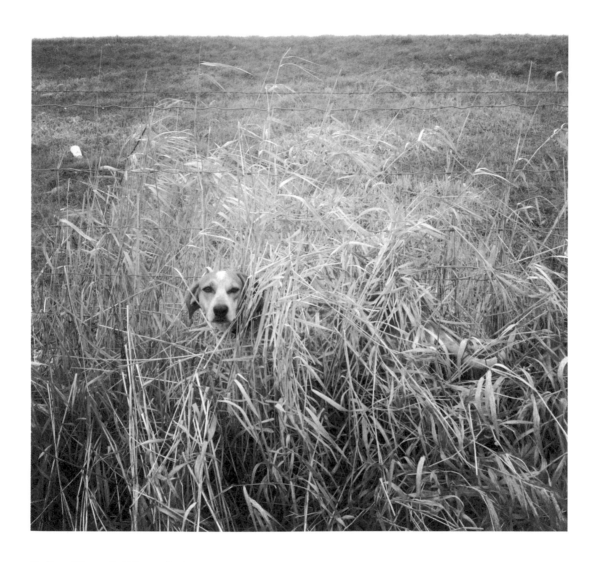

Madison, Wisconsin, February 21, 2012

For most images I would pick Maddie up and ask her to stay, with the promise of lots of treats afterwards. I found this great patch of grass for Maddie to blend into near a McDonald's parking lot of all places. This is one of those subtle images I came to love as we traveled. It's always amazes me how a photograph can transform a space.

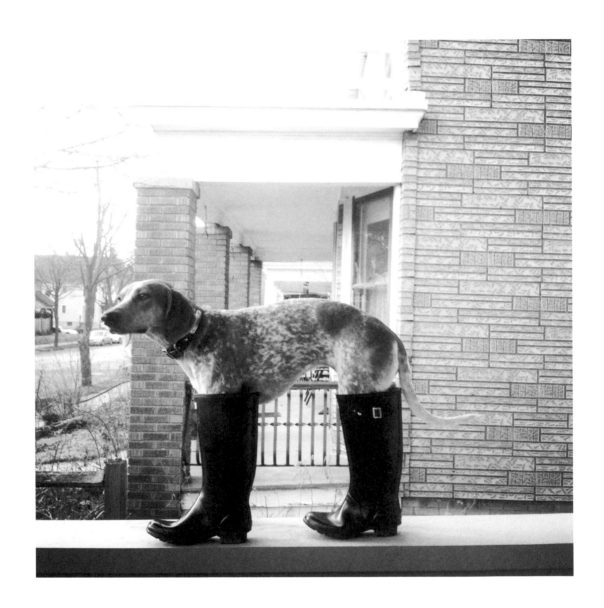

Milwaukee, Wisconsin, February 22, 2012

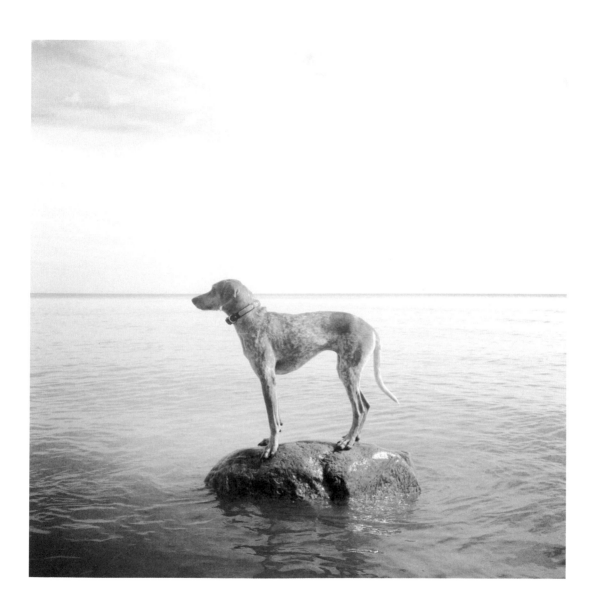

Milwaukee, Wisconsin, February 22, 2012

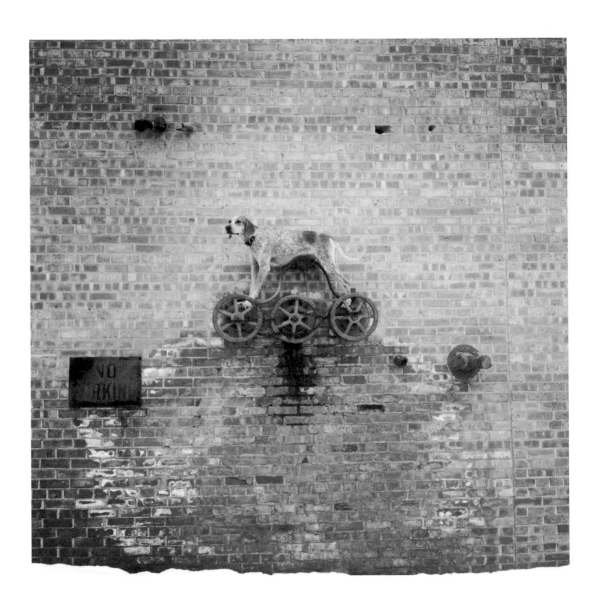

Milwaukee, **Wisconsin**, February 24, 2012

50

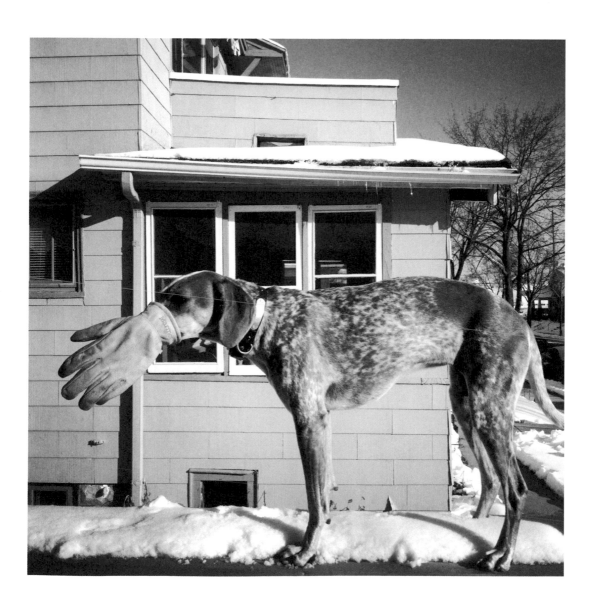

Milwaukee, Wisconsin, February 25, 2012

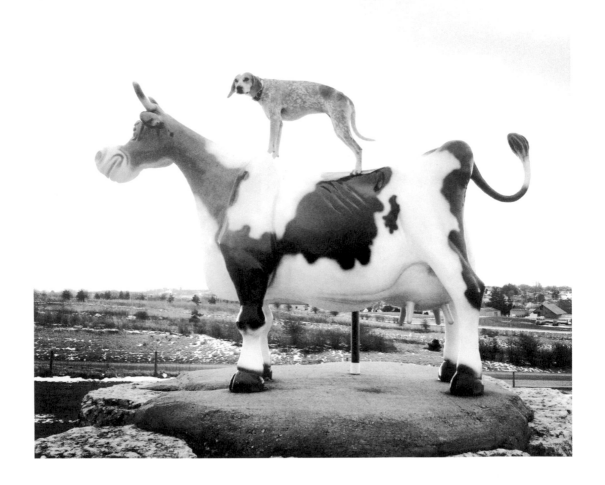

Belmont, **Wisconsin**, February 27, 2012

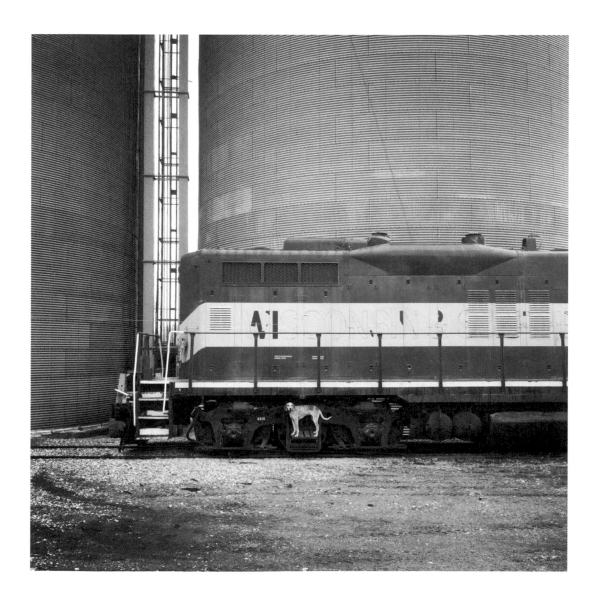

Dows, Iowa, February 28, 2012

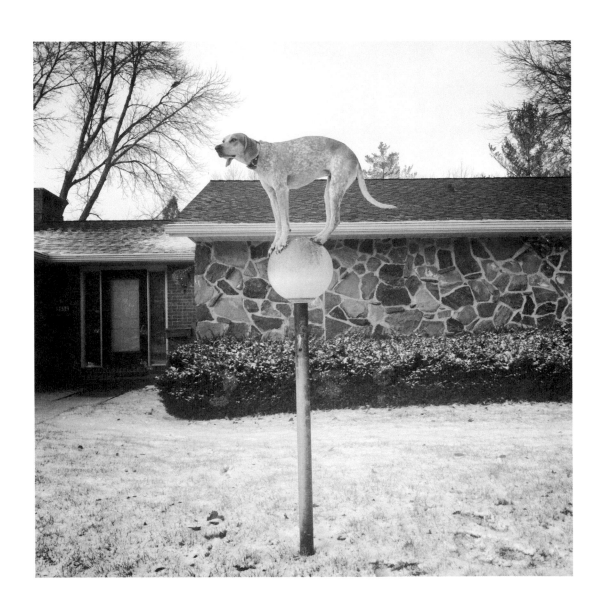

Ames, **Iowa**, March 1, 2012
This image blew my mind. Maddie didn't slip or wobble at all. Hats off to the sticky patch of
moss on top of the globe!

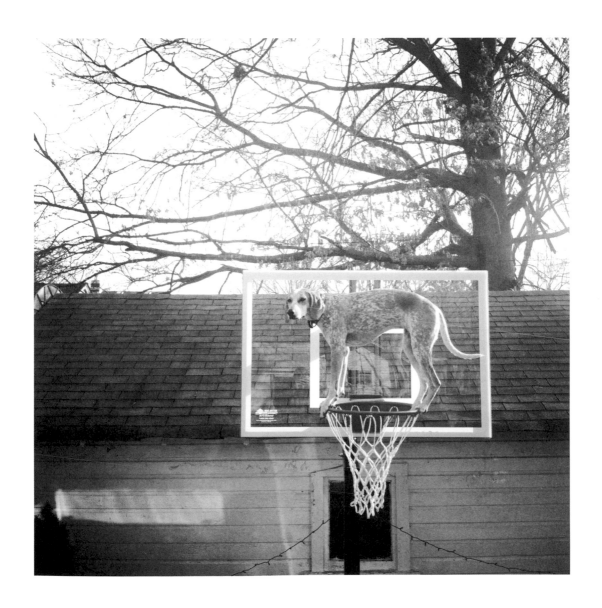

Des Moines, Iowa, March 1, 2012

I'm often on the fence about whether I should share backstories to photographs. I like that photographs can be mysterious. But I often get asked to tell the story of this image. Right underneath the basketball net is my pickup truck that has a camper shell on it.

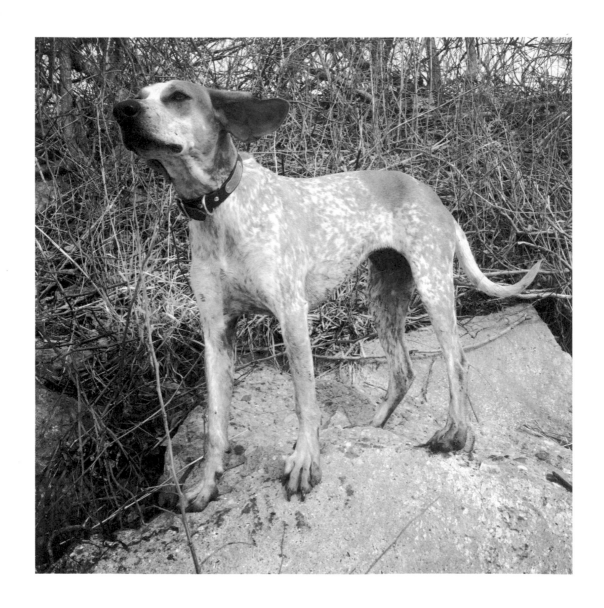

Des Moines, Iowa, March 2, 2012

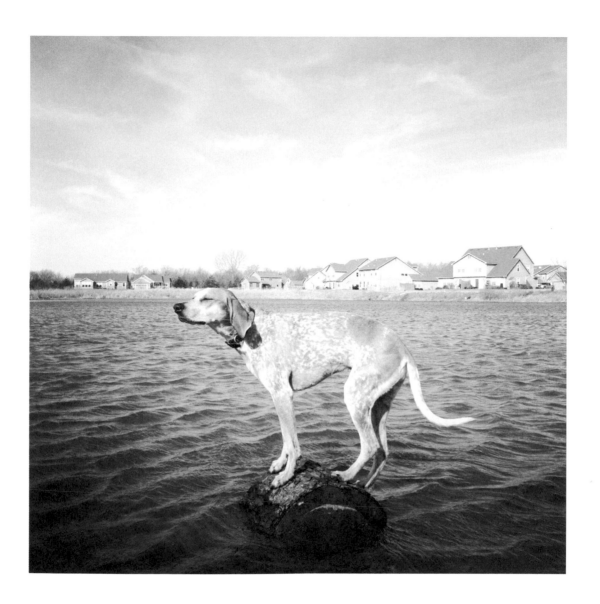

Lawrence, **Kansas**, March 6, 2012

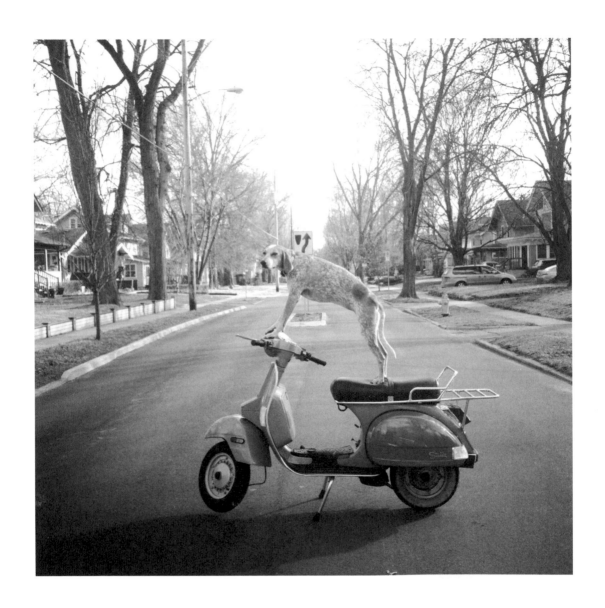

Des Moines, Iowa, March 3, 2012

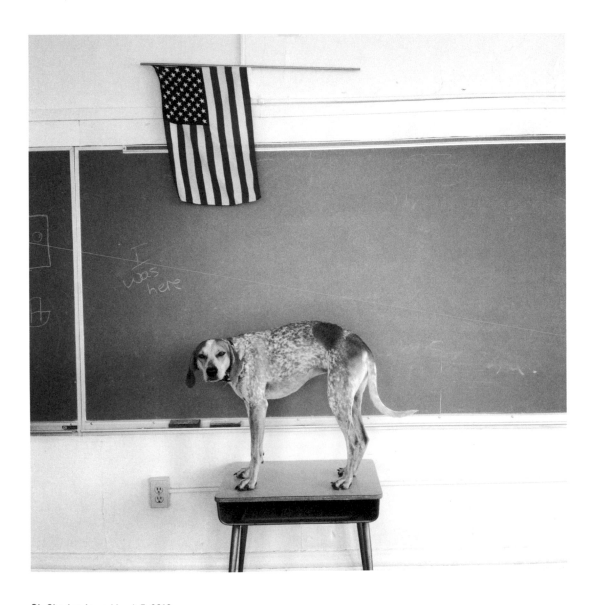

St. Charles, Iowa, March 5, 2012

In this little town in Iowa, Maddie and I explored an old elementary school. It was the sort of building that was made of brick and three stories tall. The best part of old spaces is imaging all the stories that happened there. Thinking of all the folks that called that classroom home. I loved the writing on the chalkboard.

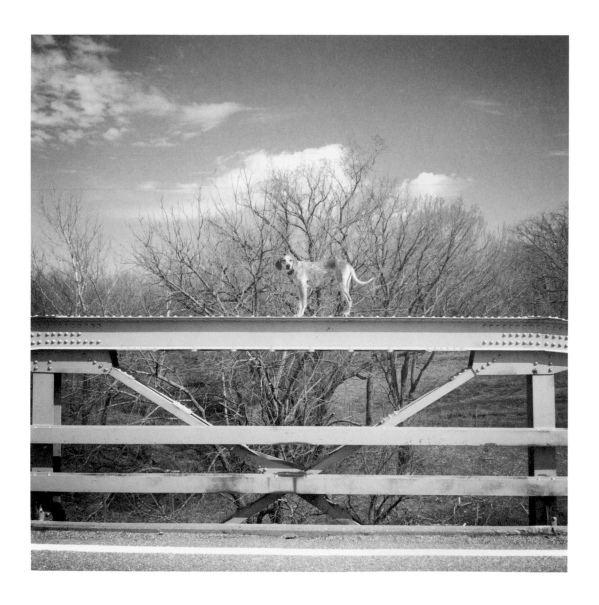

Bartlesville, Oklahoma, March 10, 2012

Columbus, Indiana

Williston, North Dakota

Tulsa, Oklahoma

Grand Teton National Park, Wyoming

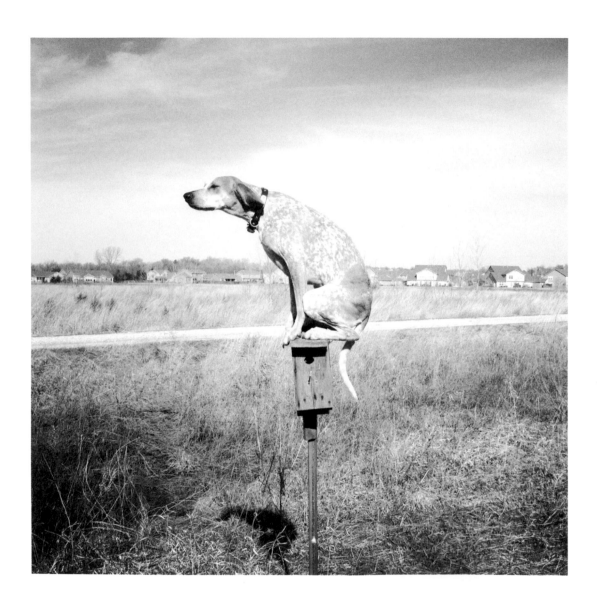

Lawrence, **Kansas**, March 6, 2012

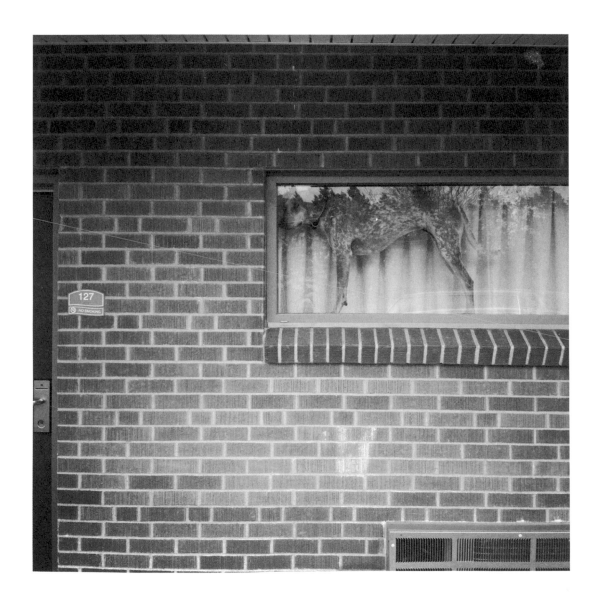

Shawnee, **Kansas**, March 7, 2012

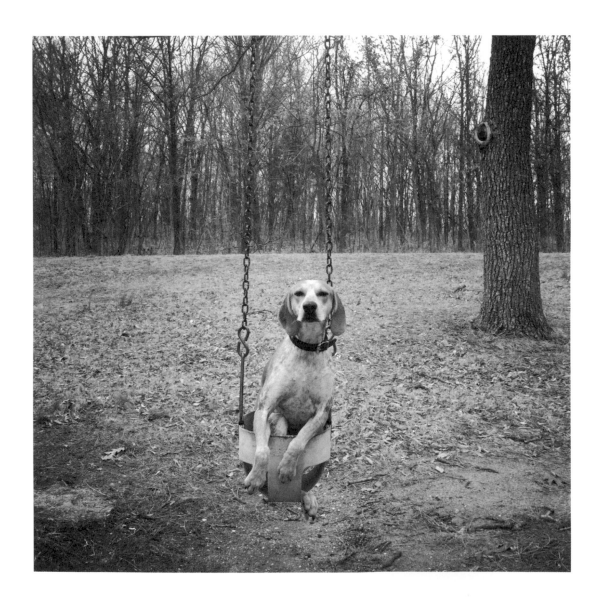

Wyandotte County Lake Park, Kansas, March 7, 2012

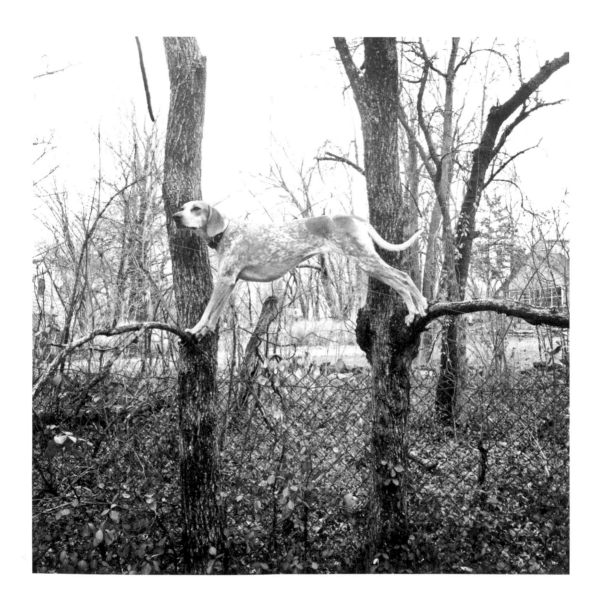

Shawnee, **Kansas**, March 8, 2012

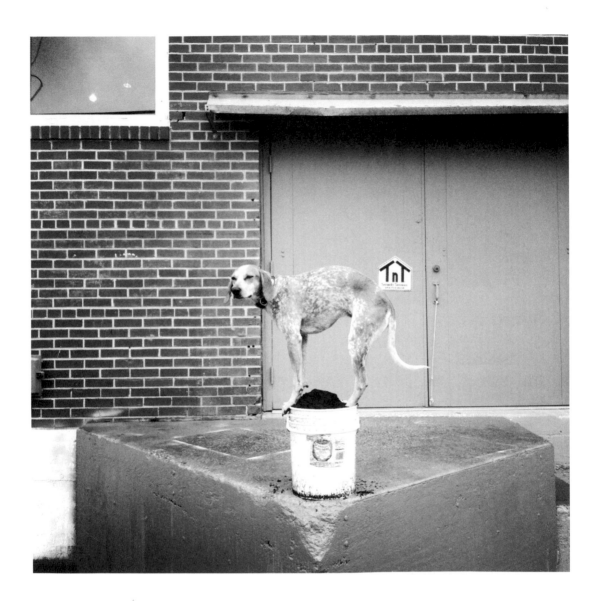

Tulsa, **Oklahoma**, March 11, 2012

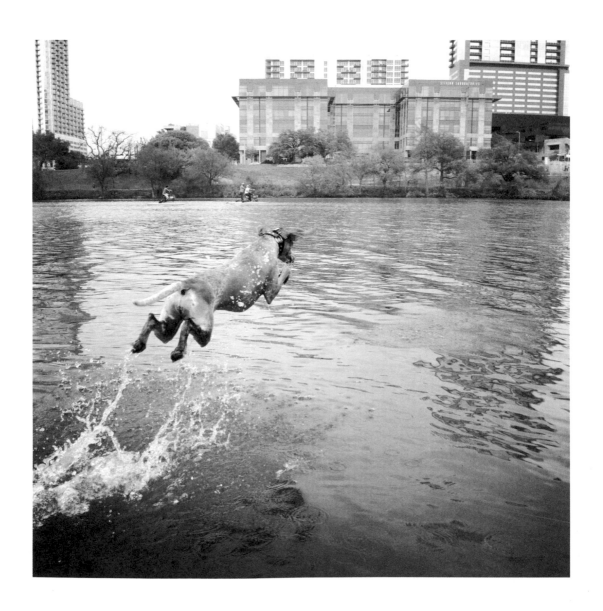

Austin, **Texas**, March 14, 2012

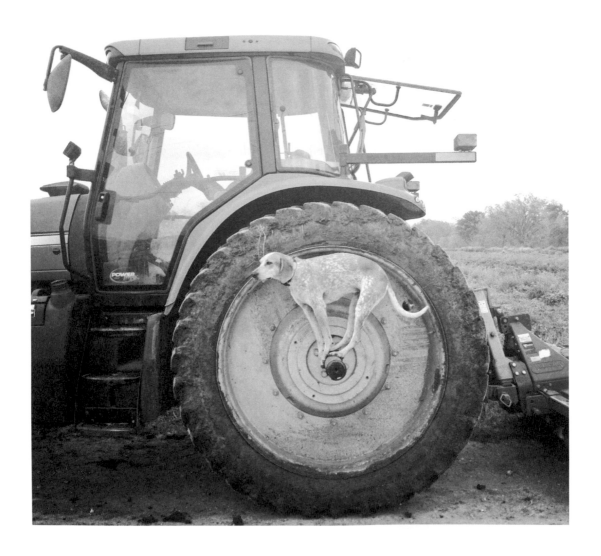

Austin, **Texas**, March 15, 2012

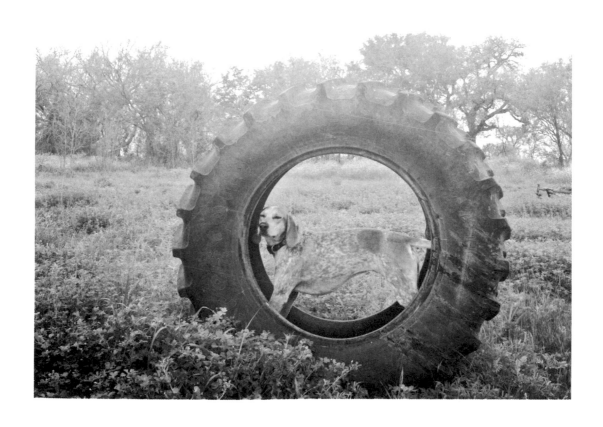

Austin, Texas, March 15, 2012

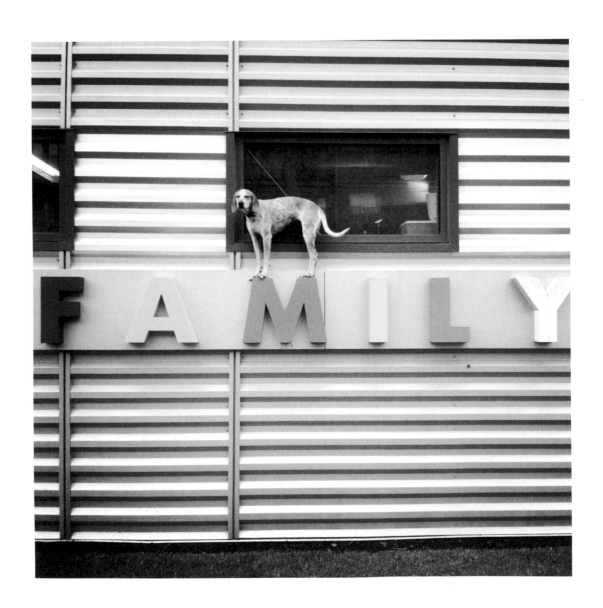

Houston, **Texas**, March 20, 2012

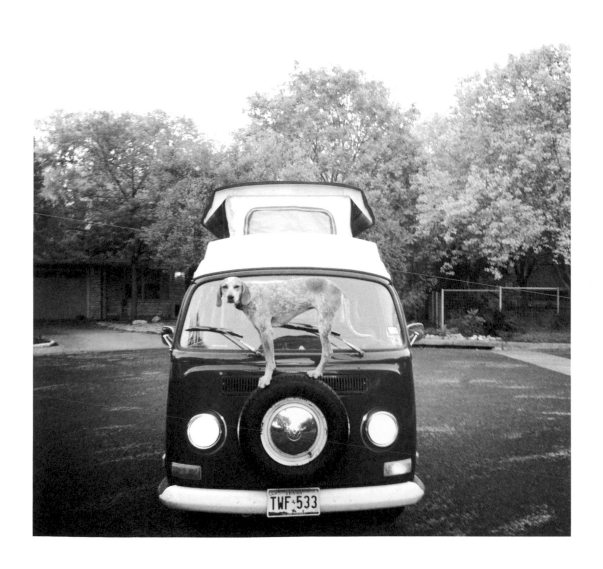

Austin, **Texas**, March 15, 2012
Maura and Chap down in Austin, Texas own this great VW van. They are such amazing folks.
I spent a few days with them in the city and countryside, just driving around and enjoying life.

71

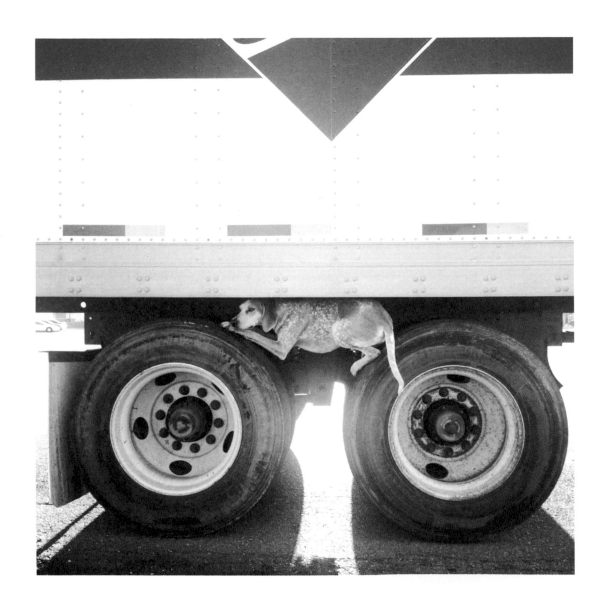

Lawton, **Oklahoma**, March 13, 2012

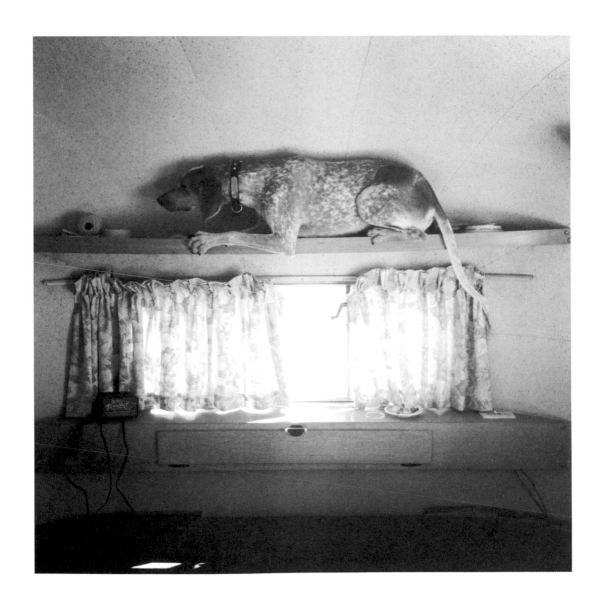

Marfa, **Texas**, March 22, 2012

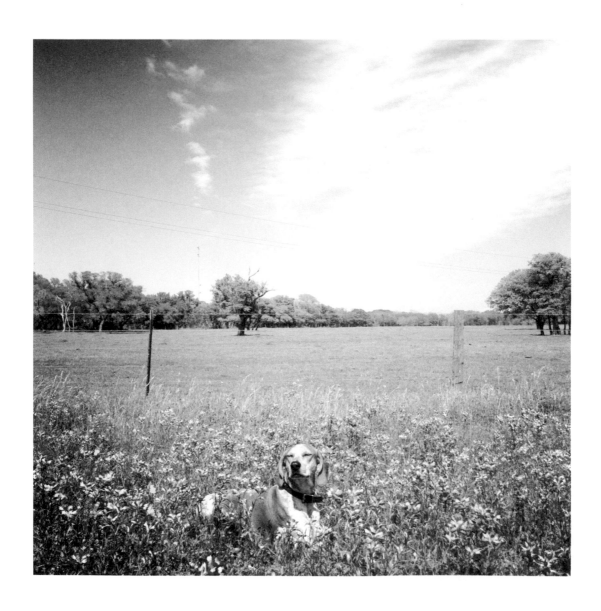

Glidden, **Texas**, March 21, 2012

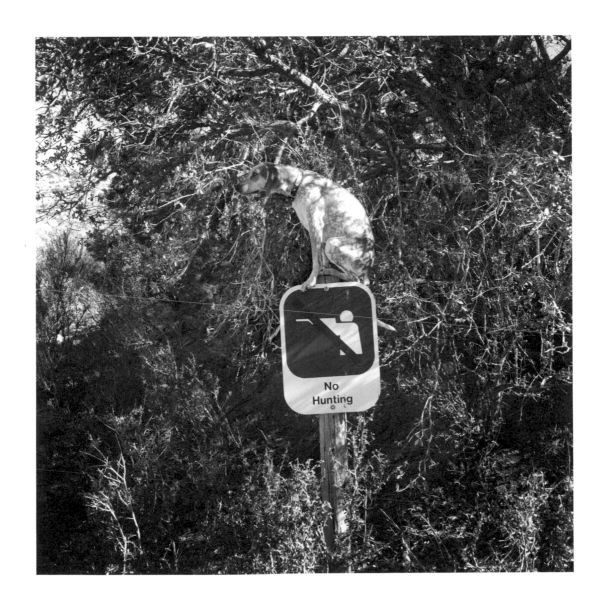

Las Cruces, **New Mexico**, March 23, 2012

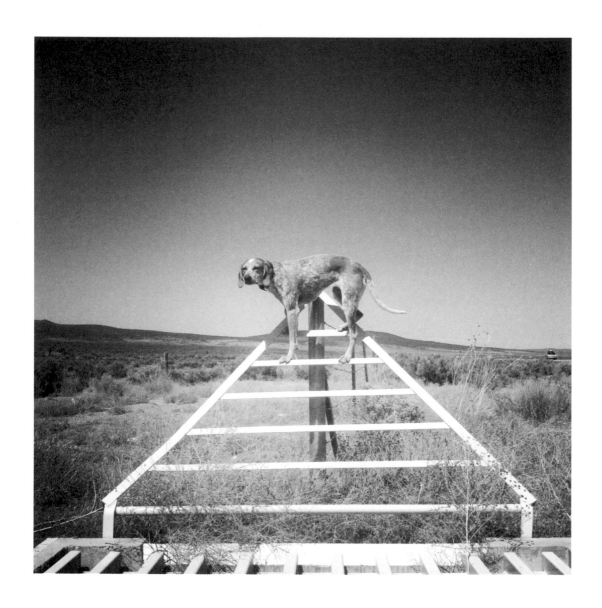

Taos, **New Mexico**, March 27, 2012

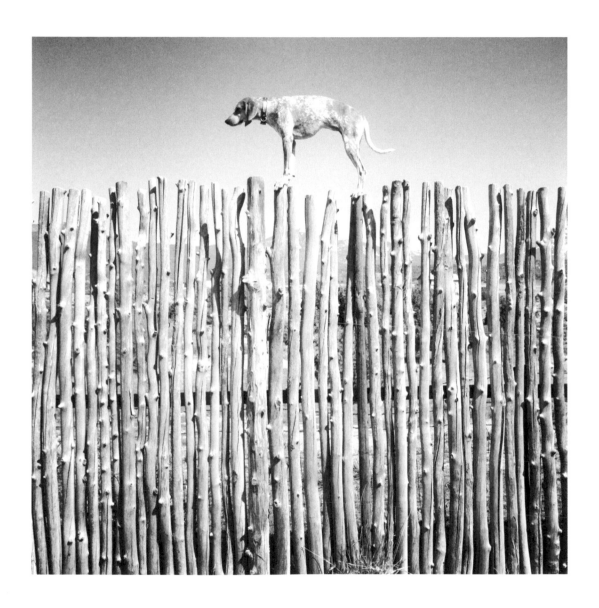

Arroyo Hondo, **New Mexico**, March 26, 2012

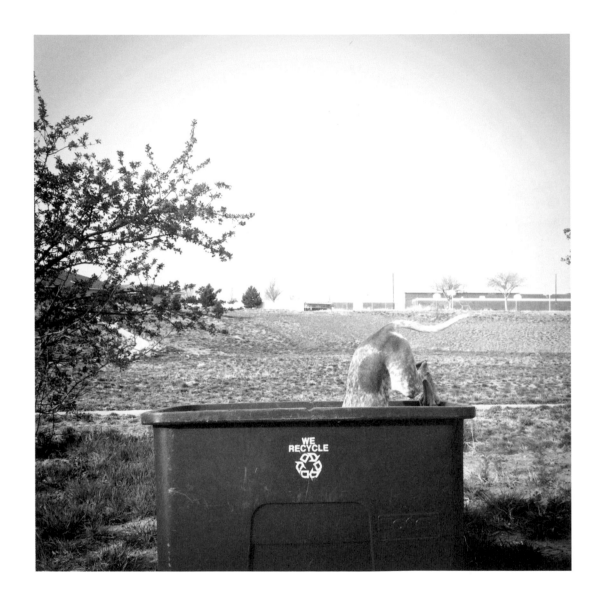

Pueblo, **Colorado**, March 29, 2012

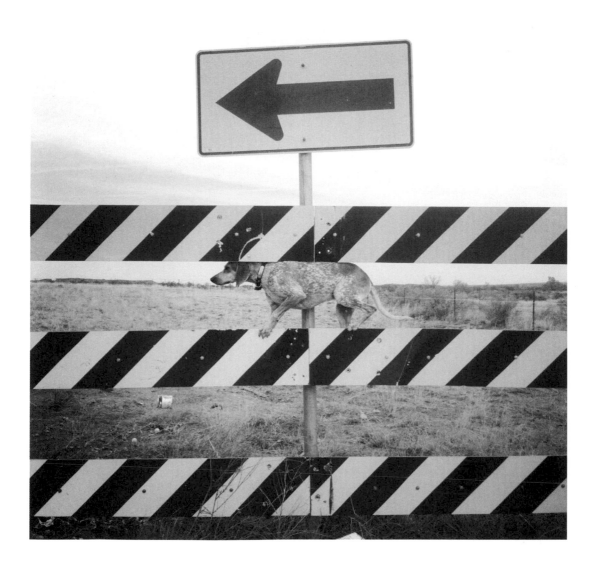

Pueblo, **Colorado**, March 29, 2012

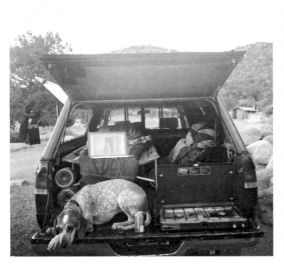

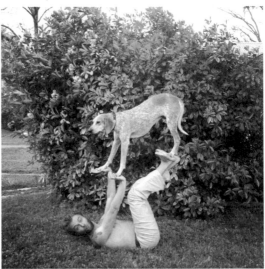

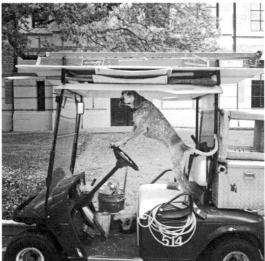

Las Cruces, New Mexico

Austin, Texas

Harrisburg, Pennsylvania

Houston, Texas

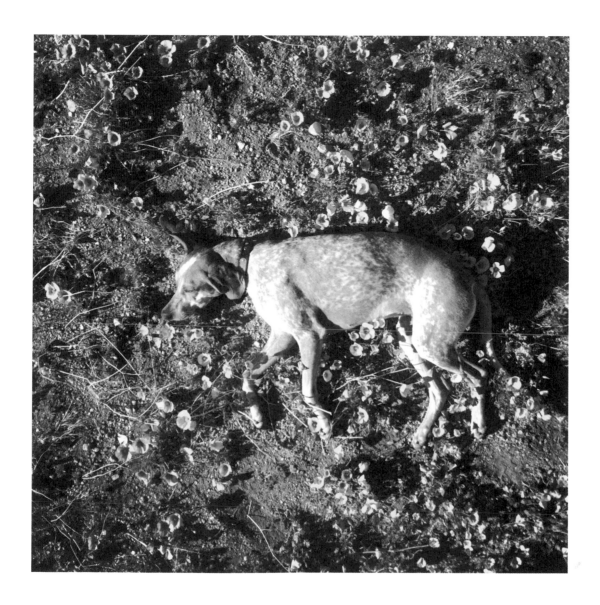

Las Cruces, **New Mexico**, March 23, 2012

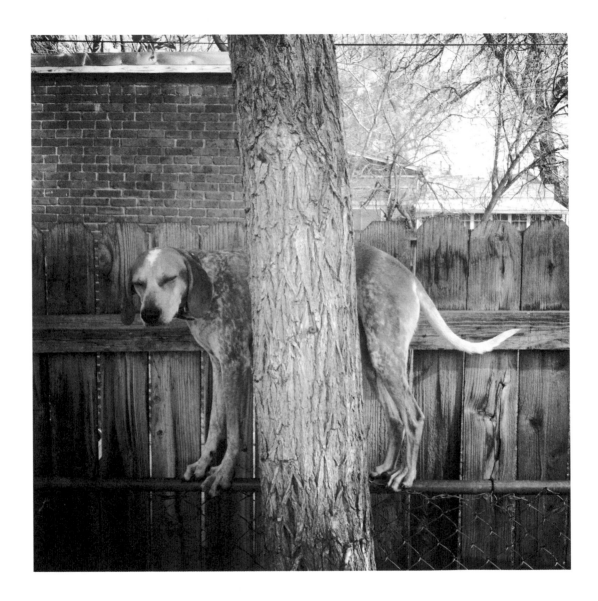

Denver, **Colorado**, March 30, 2012

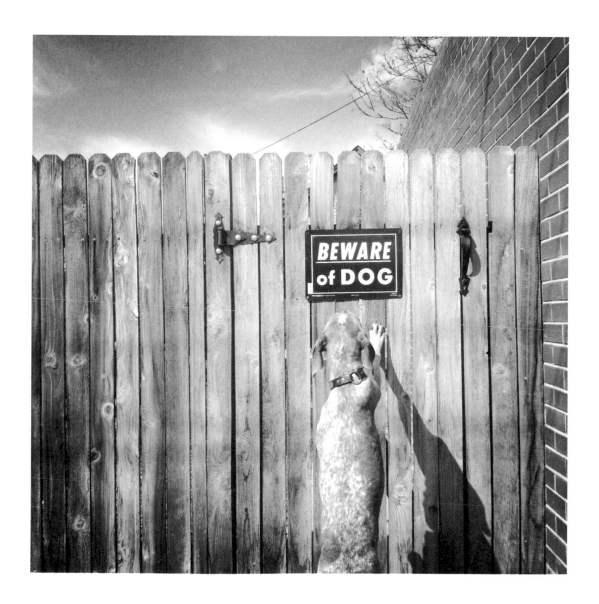

Denver, **Colorado**, March 30, 2012

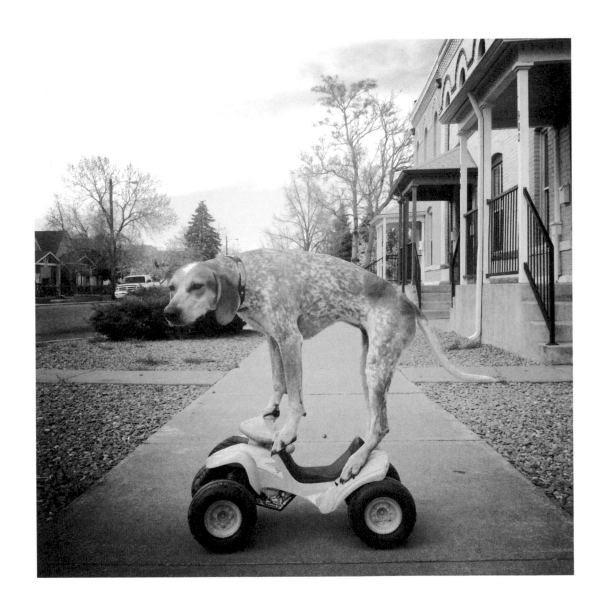

Denver, **Colorado**, March 30, 2012

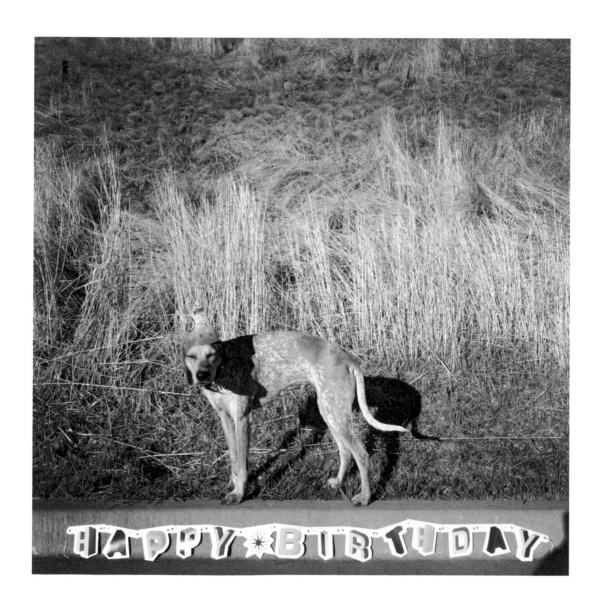

Glenwood Springs, **Colorado**, April 1, 2012

Maddie's birthday is April 1. This year she turned two. The day before we stopped at a dollar store and got a few decorations and treats. That morning we woke up, ate well, and celebrated with tiny hats.

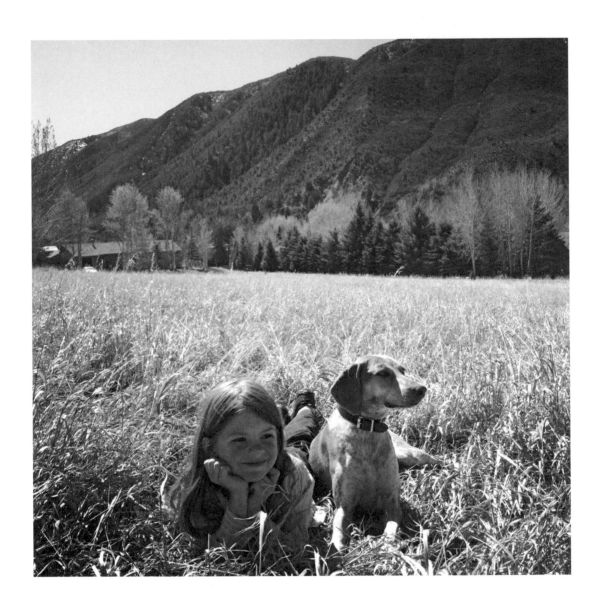

Basalt, **Colorado**, April 1, 2012

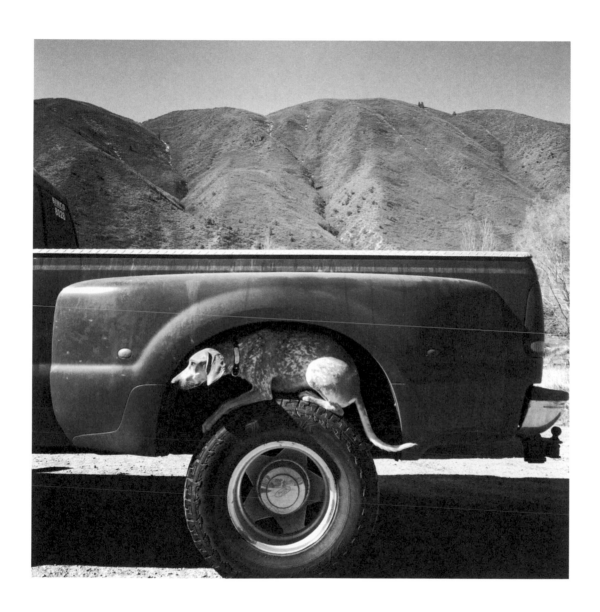

Basalt, Colorado, April 1, 2012
This is my favorite Maddie image. I love how the curve of her body mimics the mountains.
I love the play of colors. And I love how simply the image came together.

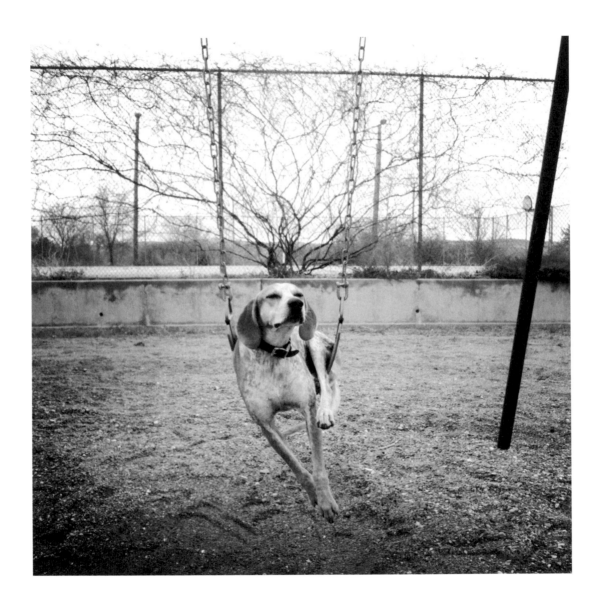

Wauneta, **Nebraska**, April 3, 2012

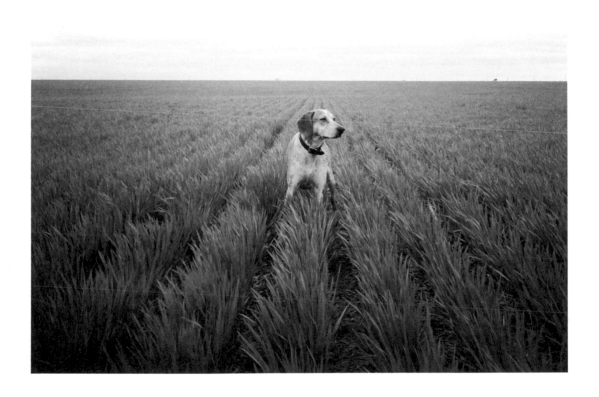

McCook, **Nebraska**, April 3, 2012

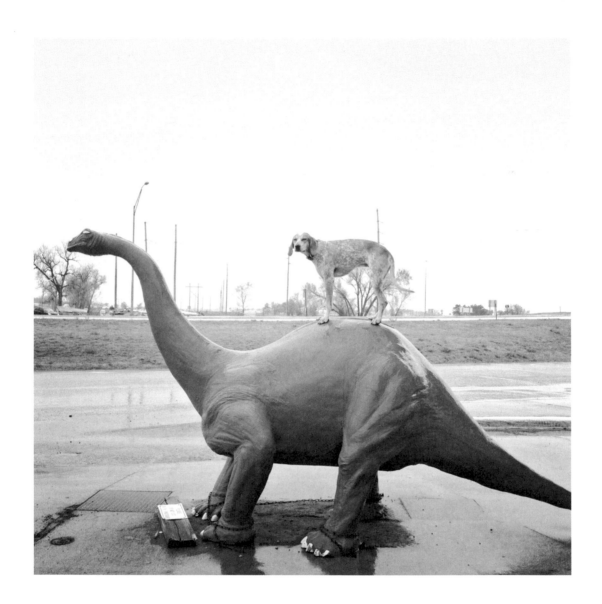

Lexington, Nebraska, April 4, 2012
A movie from my childhood that always stuck with me was *Pee-Wee's Big Adventure*. I always remember those dinosaurs. We stopped to fill up in Nebraska and I couldn't pass up a green dinosaur. The best part was the truck driver that stopped and waved.

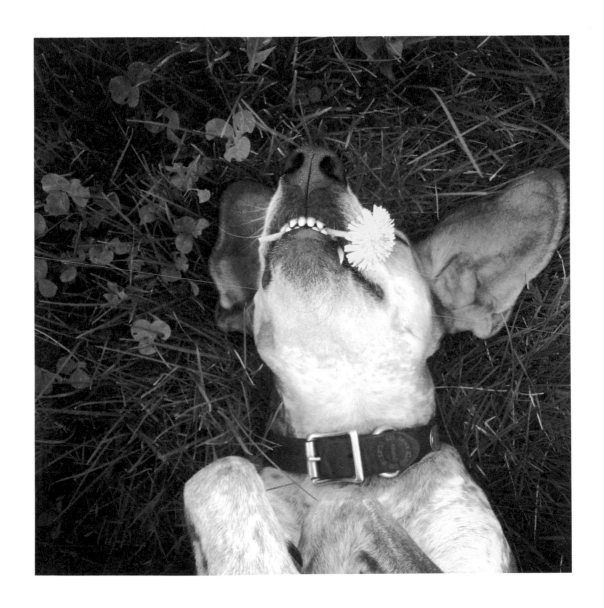

Lincoln, Nebraska, April 4, 2012

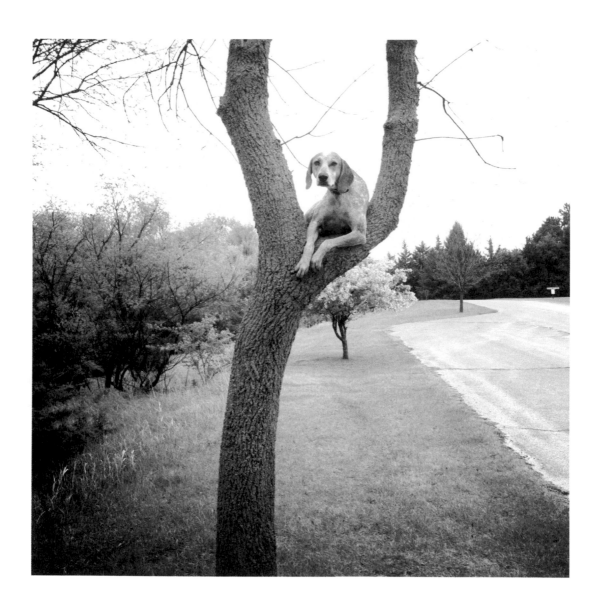

Kearney, **Nebraska**, April 4, 2012

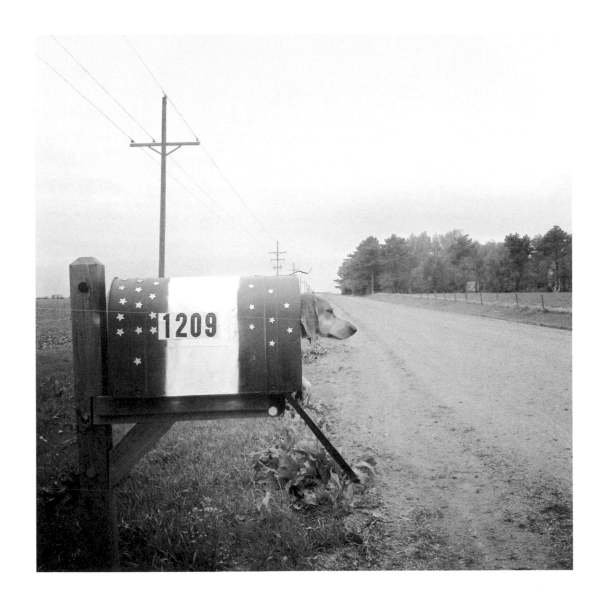

York, Nebraska, April 4, 2012

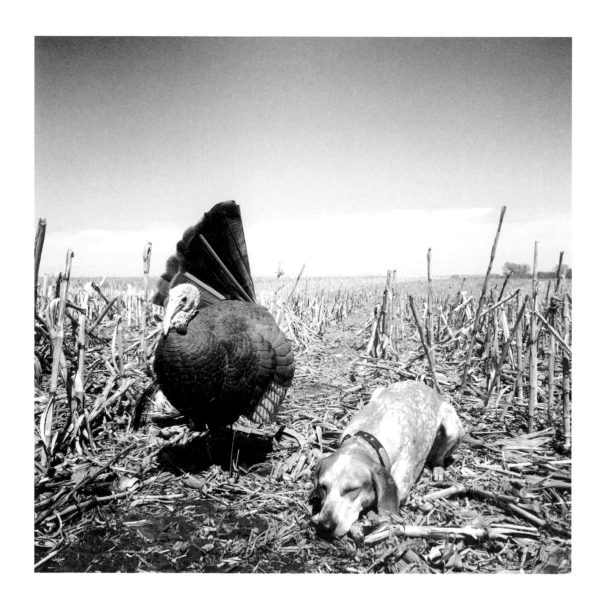

Auburn, Nebraska, April 6, 2012

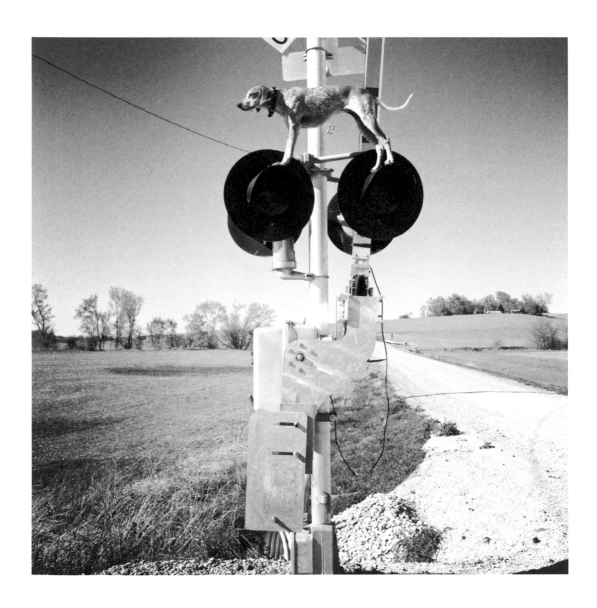

Blaire, **Nebraska**, April 7, 2012

Omaha, **Nebraska**, April 8, 2012

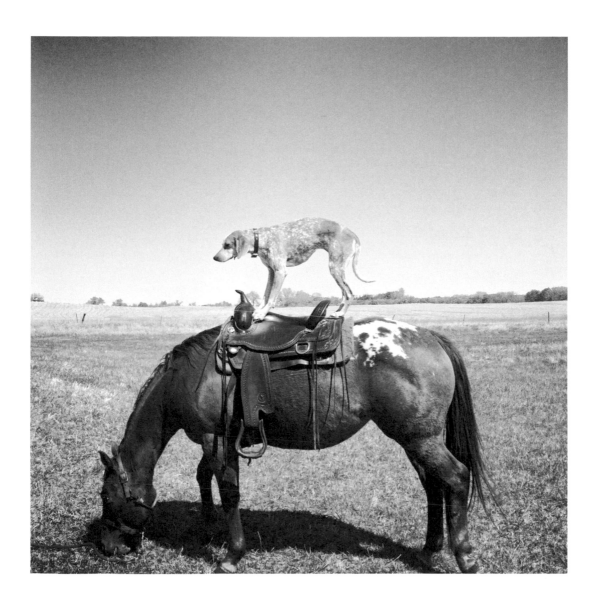

Yankton, South Dakota, April 9, 2012

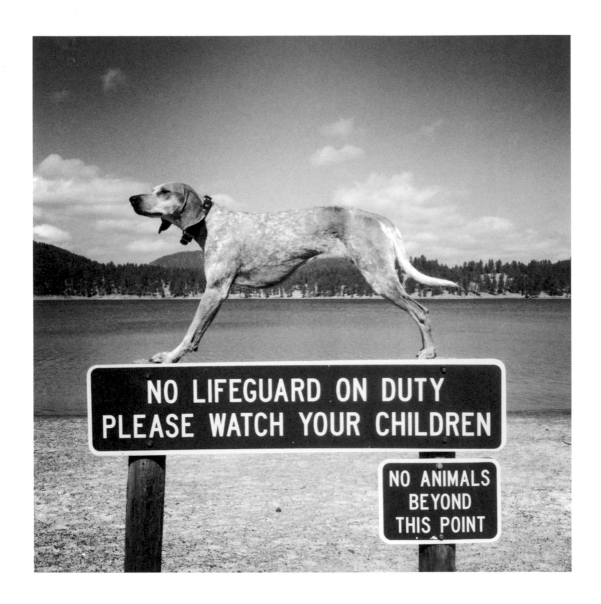

Pactola Reservoir, South Dakota, April 11, 2012

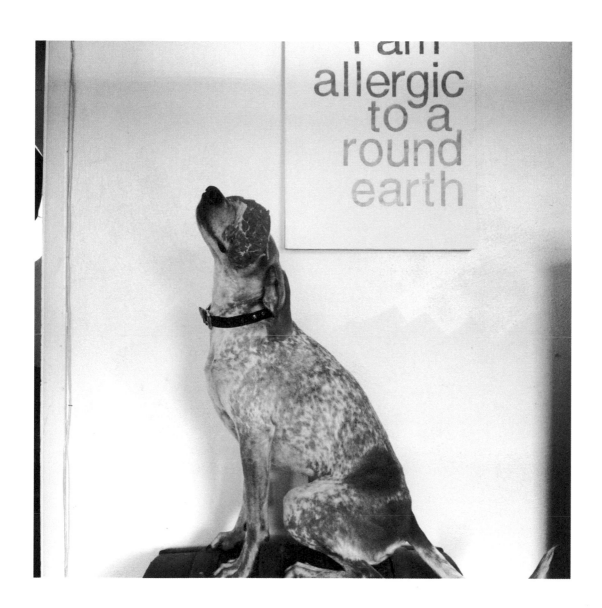

I am
allergic
to a
round
earth

Rapid City, **South Dakota**, April 12, 2012

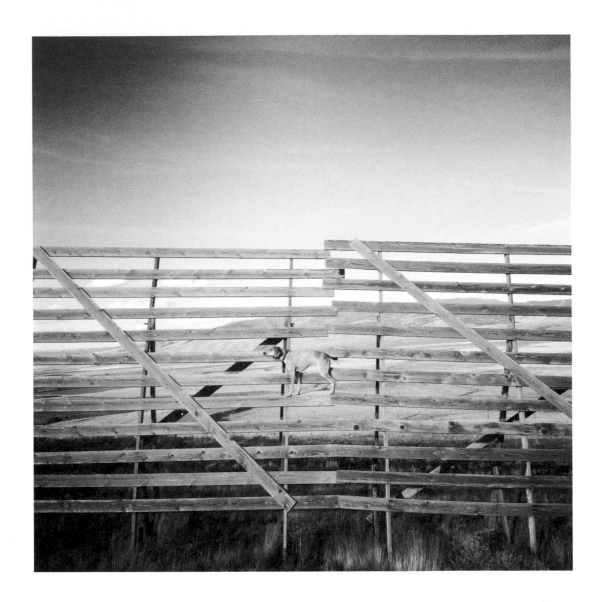

White Sulpher Springs, **Montana**, April 17, 2012

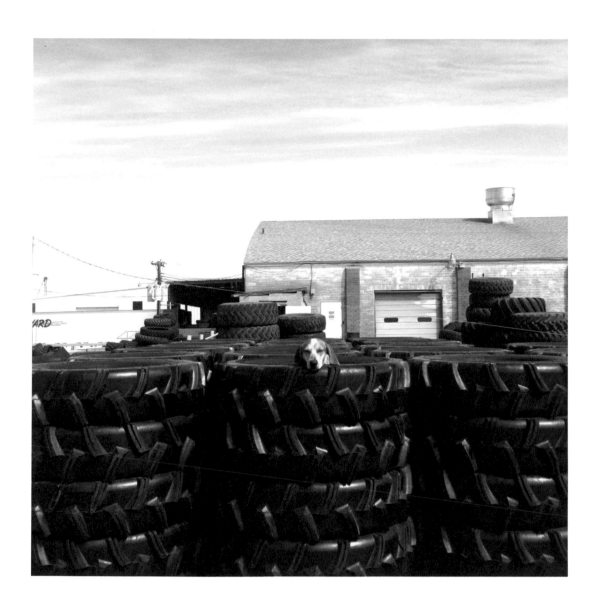

West Point, **Nebraska**, April 8, 2012

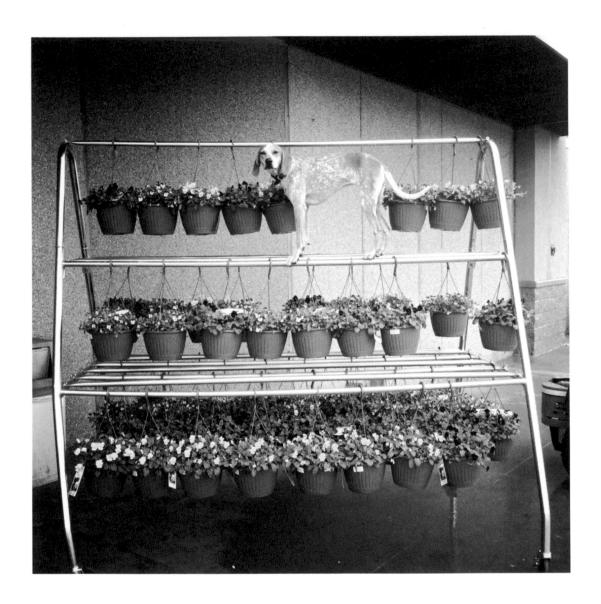

Bismarck, **North Dakota**, April 13, 2012

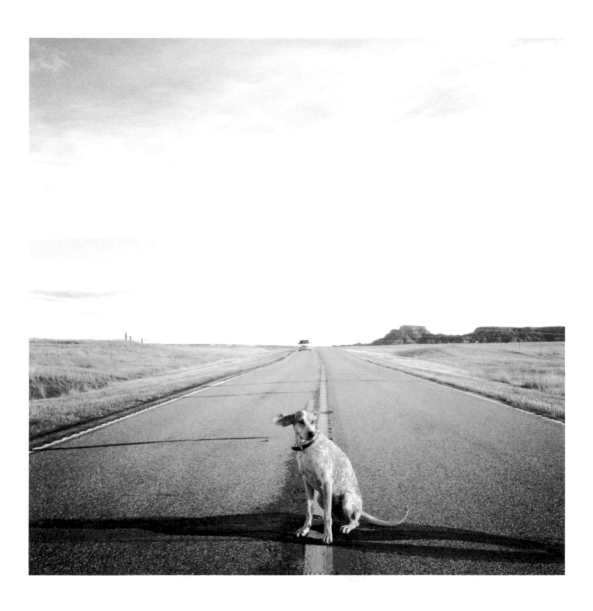

Solen, **North Dakota**, April 13, 2012

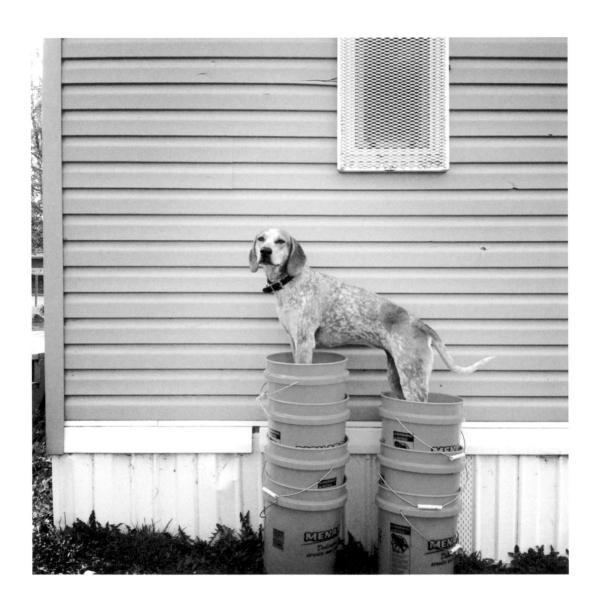

Fort Yates, North Dakota, April 14, 2012

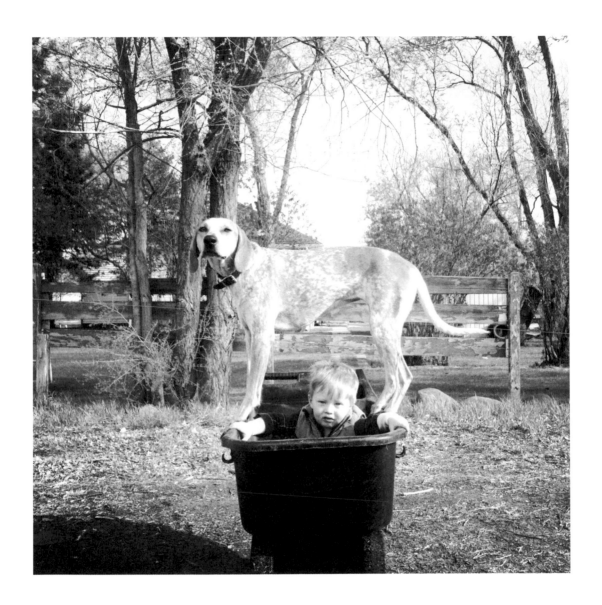

Fort Yates, **North Dakota**, April 14, 2012

Some of the best folks I met on the road live on the reservation in Fort Yates. We started building a greenhouse that afternoon. We pounded in stakes for the foundation all day. If you're ever in the area, ya'll should stop by and give them a hand.

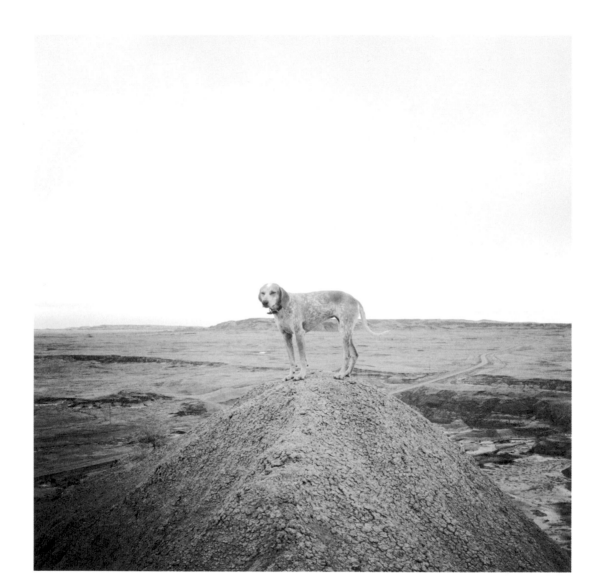

Solen, **North Dakota**, April 14, 2012

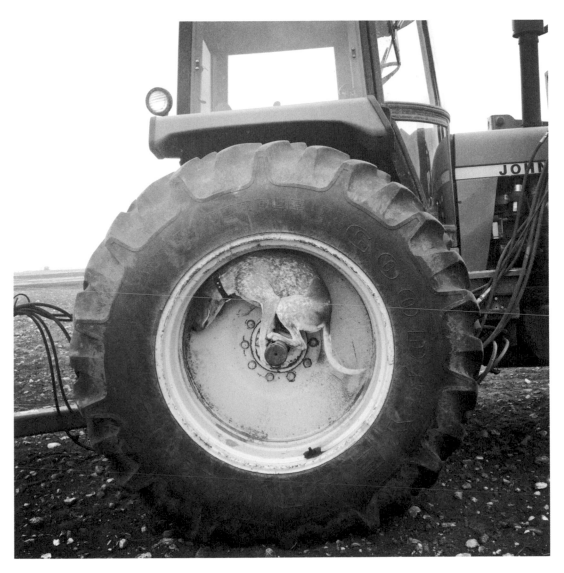

Tioga, **North Dakota**, April 15, 2012

I never grew tired of taking Maddie images. Most days I would take a new one. But even if you're doing something you love in life, it's still easy to get tunnel vision. This is an image that stirred me up again. I loved it so much. We were driving down a dirt road in North Dakota and I saw this tractor alone in the field. Its axle was long enough for two wheels on each side, and I thought I'd see if Maddie would stand on it. Thirty seconds later we were running around in celebration and Maddie was eating so many treats. I loved this shot.

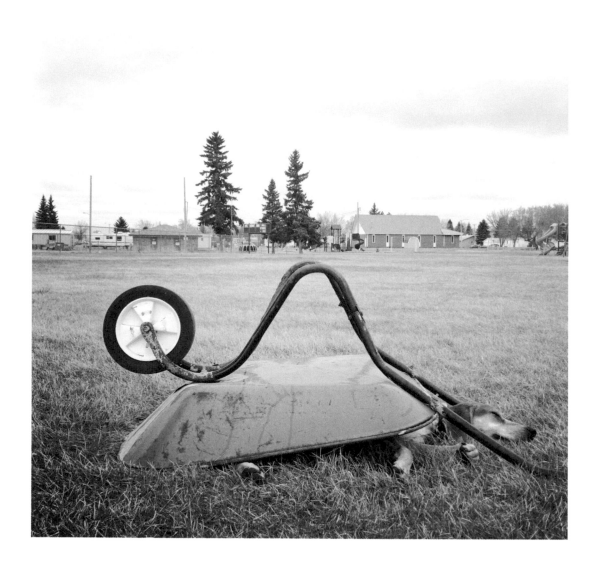

Tioga, **North Dakota**, April 16, 2012

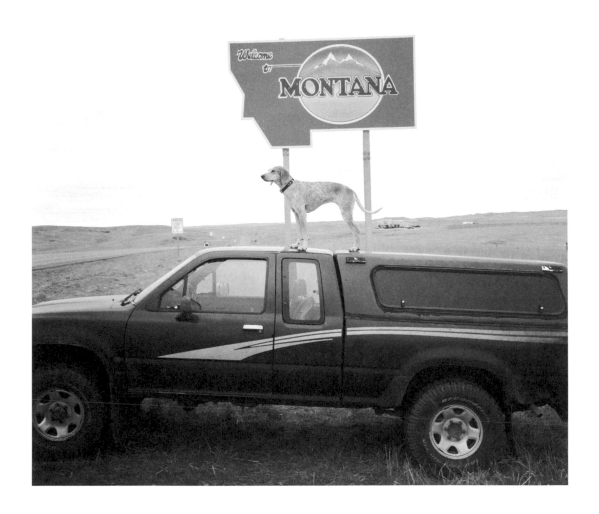

State line, near Bainville, **Montana**, April 16, 2012

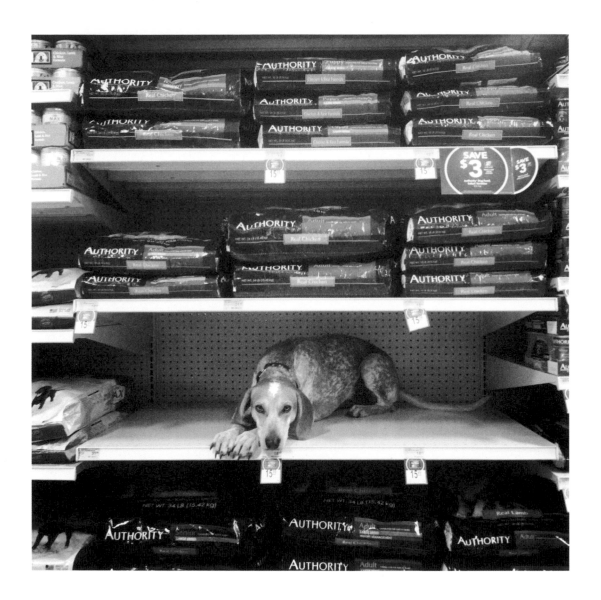

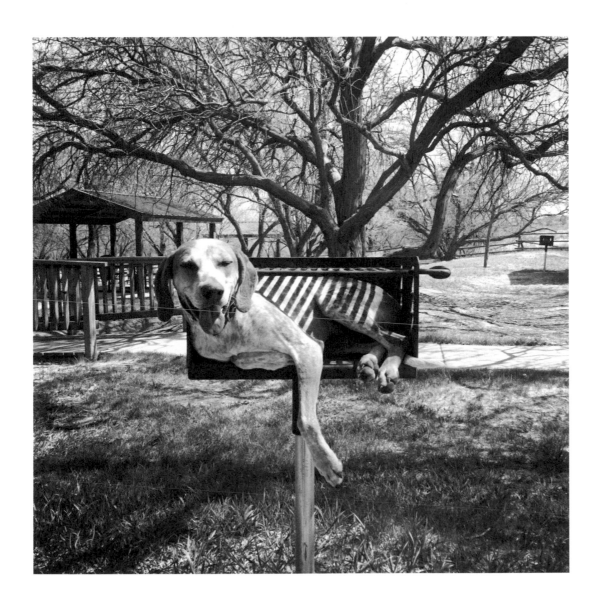

Cody, **Wyoming**, April 24, 2012

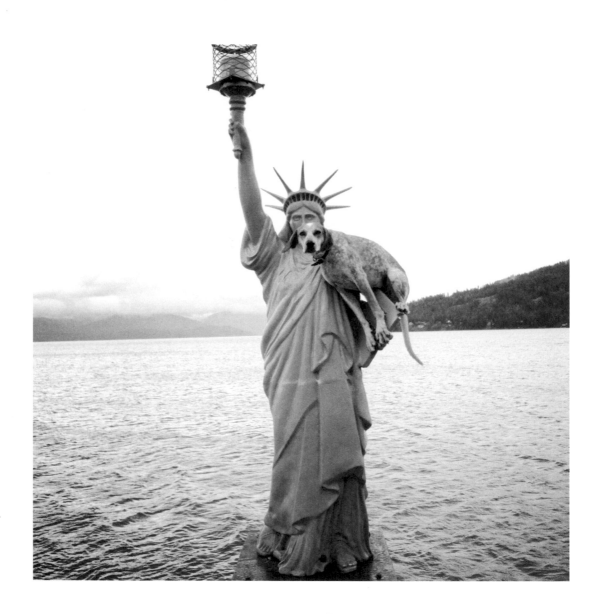

Sandpoint, Idaho, April 20, 2012
I lived in Sandpoint for a few years. This is one of those landmarks you forget about when you live in a town. But when you come back to visit, it's amazing to remember there is a tiny State of Liberty there.

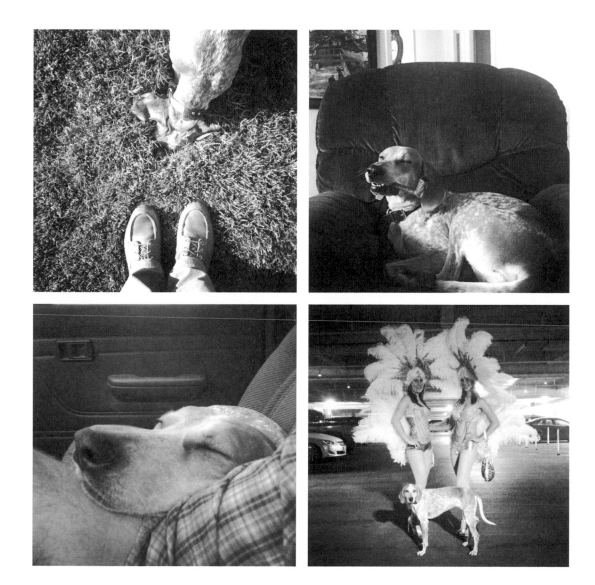

Inglewood, California

Encinitas, California

San Bernadino, California

Las Vegas, Nevada

Libby, **Montana**, April 21, 2012

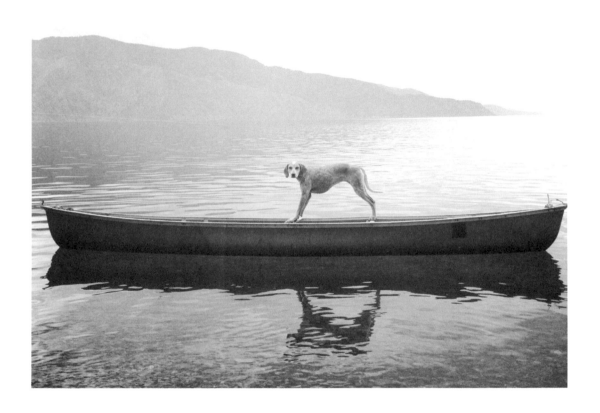

Sandpoint, **Idaho**, June 12, 2012

Cody, **Wyoming**, April 24, 2012

116

Lander, **Wyoming**, April 25, 2012

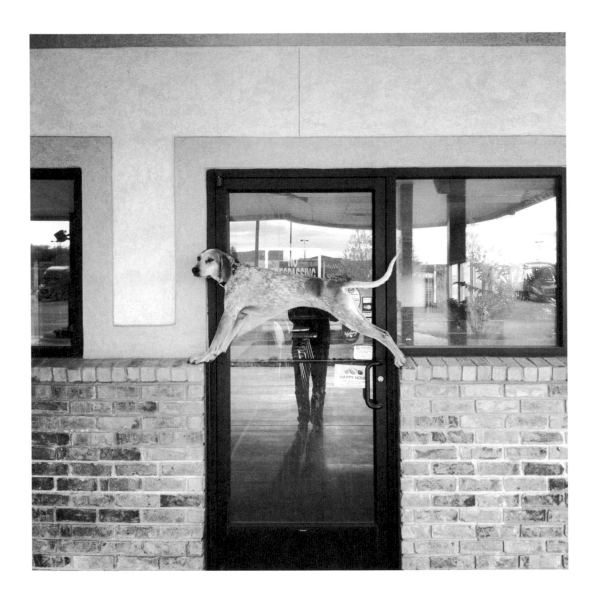

Evanston, **Wyoming**, April 26, 2012

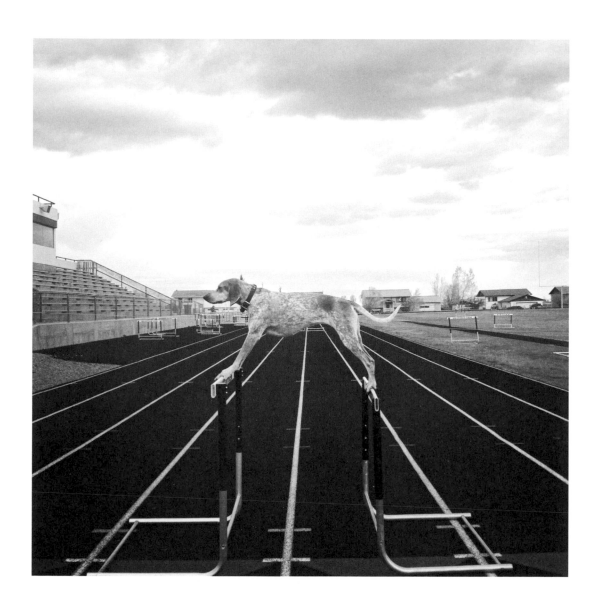

Mountain View, Wyoming, April 26, 2012

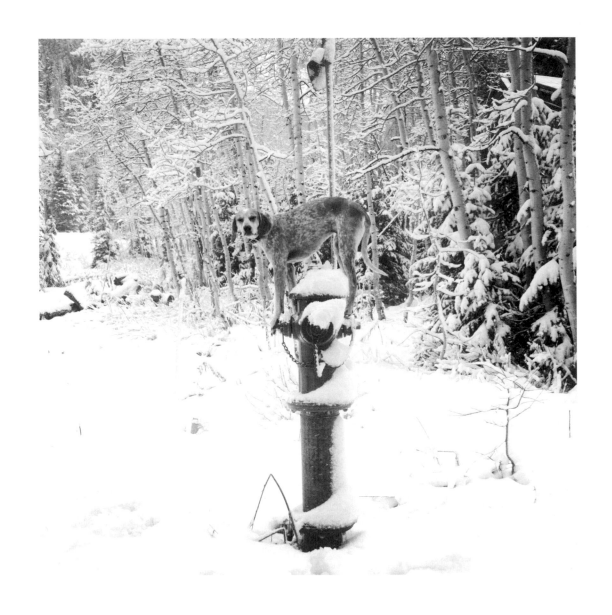

Park City, **Utah**, April 27, 2012

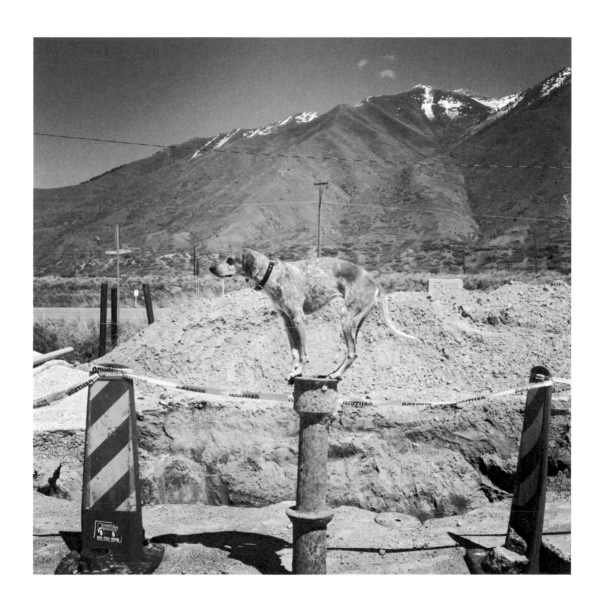

Spanish Oak, **Utah**, May 1, 2012

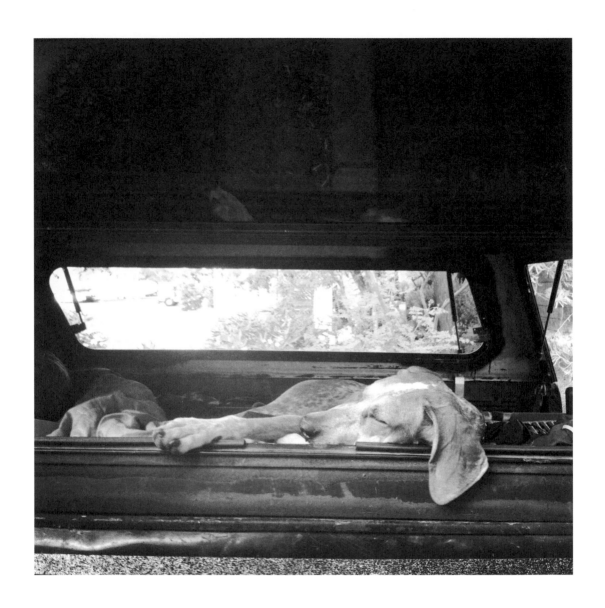

Tempe, **Arizona**, May 3, 2012

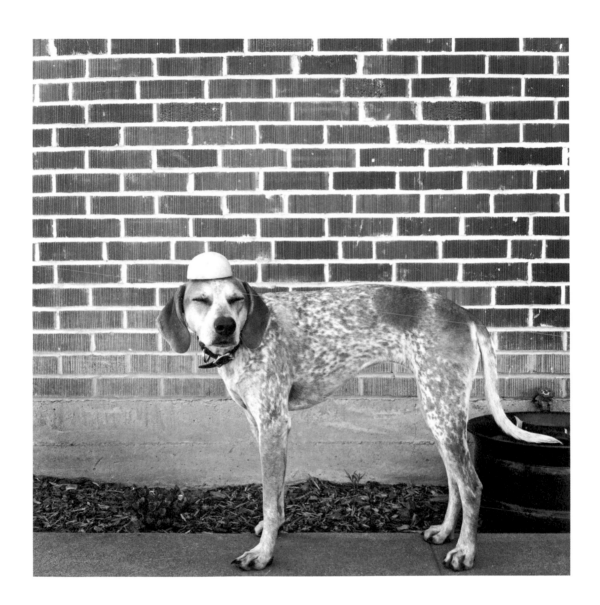

Mesa, Arizona, May 5, 2012

Our days on the road always started the same way—with coffee and breakfast. I loved that consistency. It felt like some of the only roots we had. This morning I was eating half a grapefruit. On the fly, I thought it would make a funny hat. That's what I came to love about photographing Maddie; just using what was around us to make images.

123

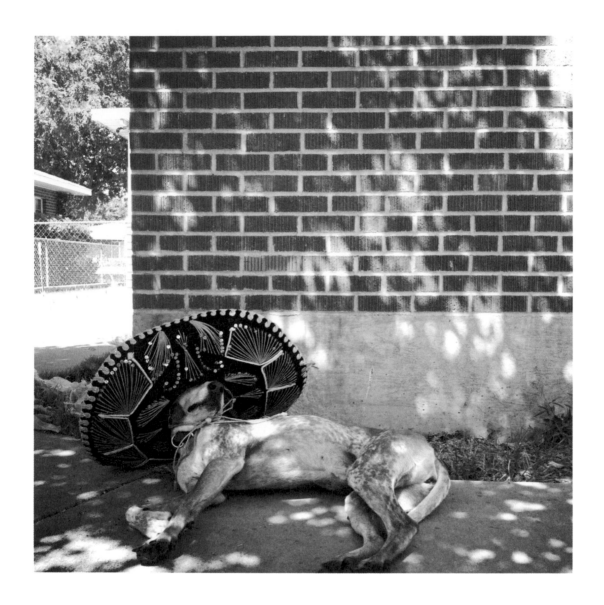

Mesa, **Arizona**, May 5, 2012

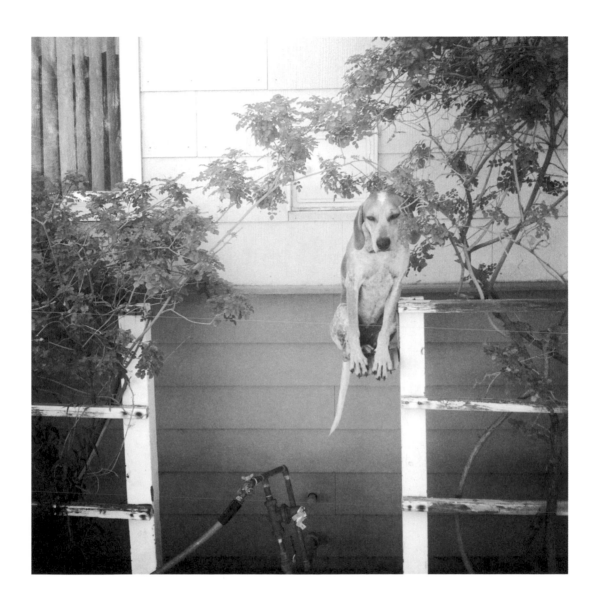

Tempe, **Arizona**, May 6, 2012

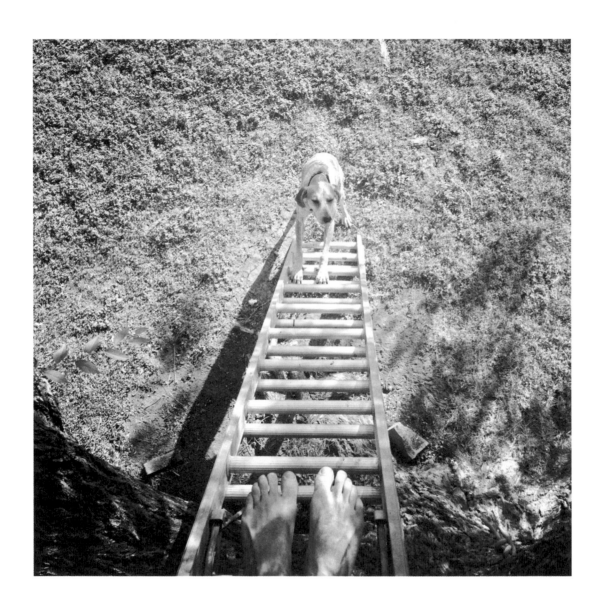

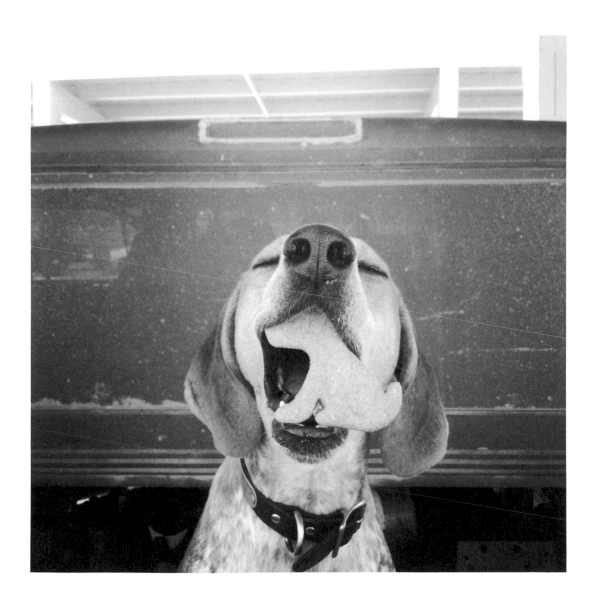

Las Vegas, **Nevada**, May 10, 2012

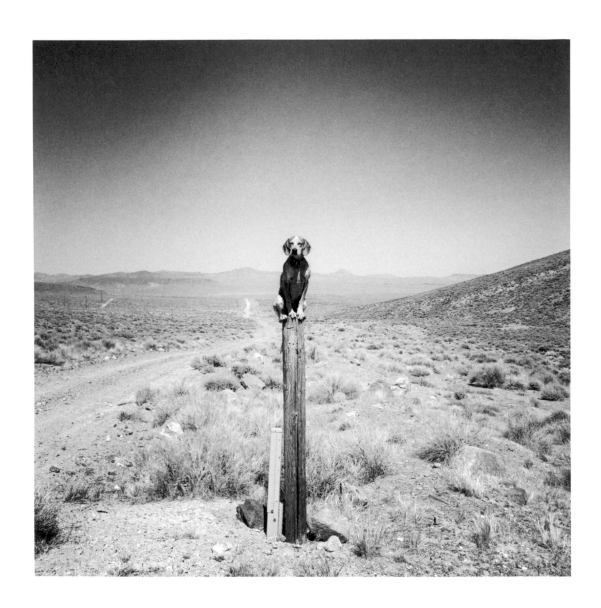

Tonopah, Nevada, May 8, 2012

Driving off paved roads always leads to good things. We packed some sandwiches and
headed into the desert looking for a good camping spot. Coming across the unexpected is
what our adventure was about. Like finding this lone pole in that desert.

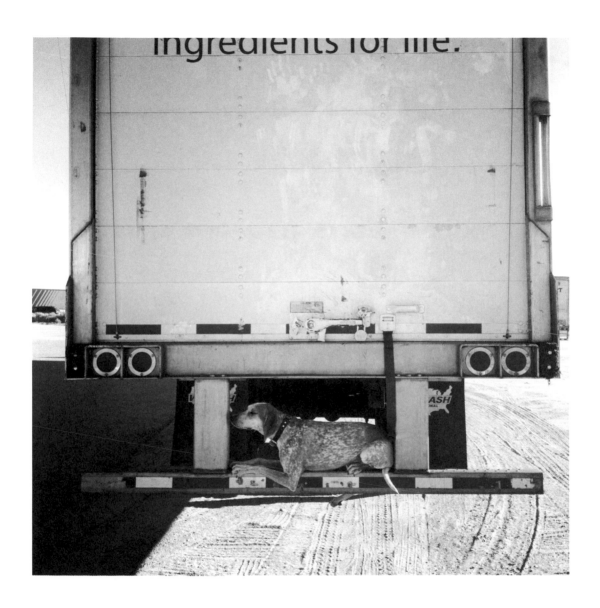

Hesperia, **California**, May 11, 2012

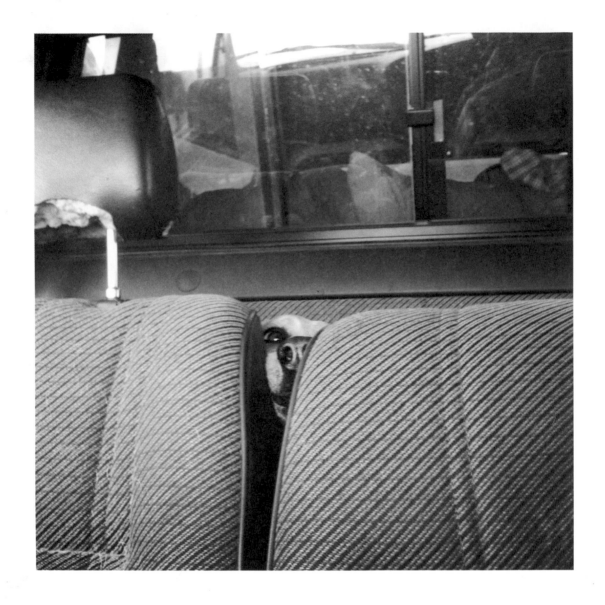

Anaheim, **California**, May 20, 2012

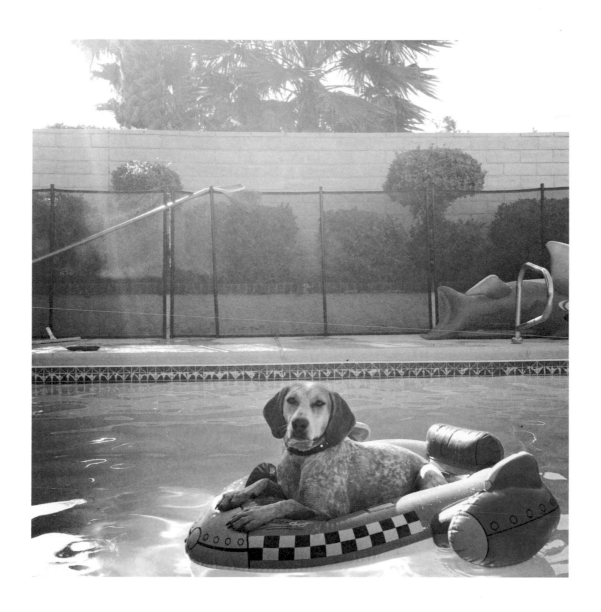

Las Vegas, **Nevada**, May 10, 2012

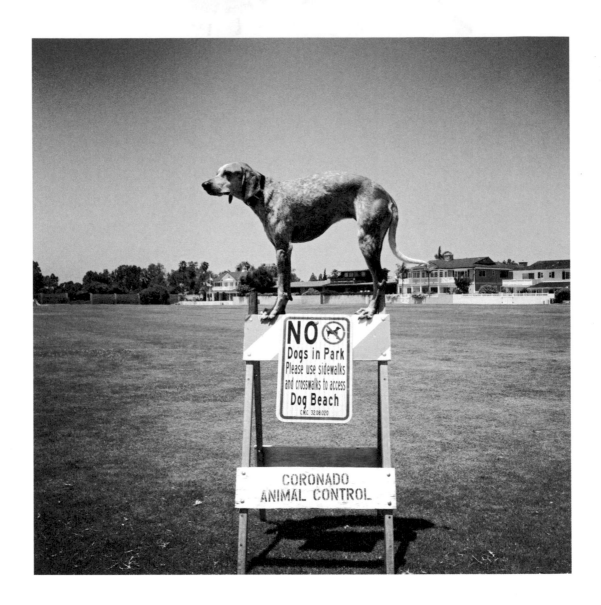

San Diego, **California**, May 11, 2012

If you've ever been to southern California, you know it's a wonderful place. But there are also a lot of rules and "no" signs. This is the best sign ever. I placed Maddie on top and 30 seconds later there was a small group of people laughing.

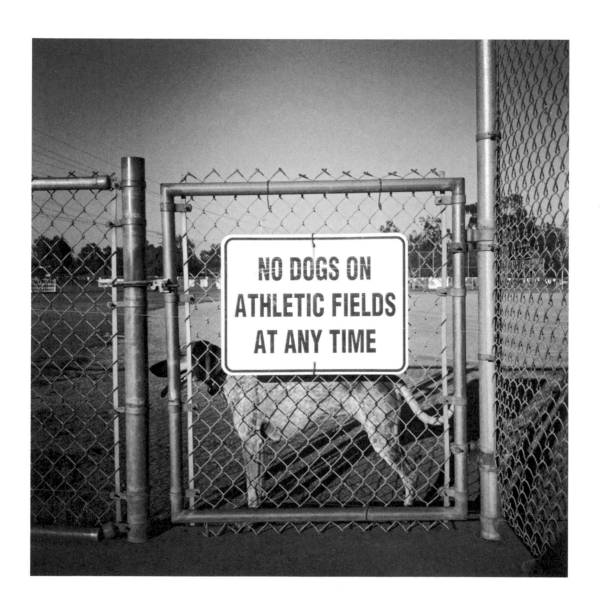

San Carlos, California, May 11, 2012

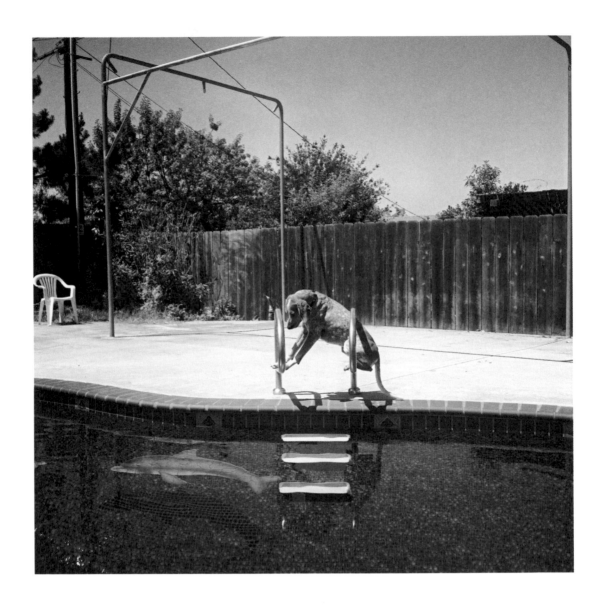

El Cajon, California, May 13, 2012

134

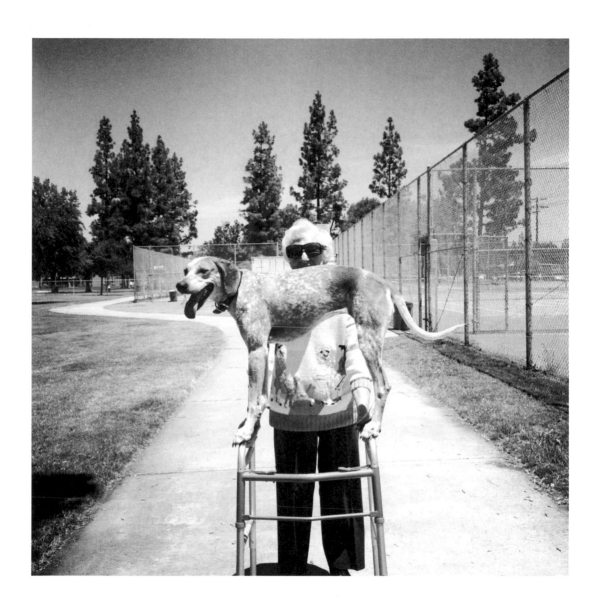

El Cajon, **California**, May 12, 2012

Mira Mesa, **California**, May 14, 2012

Sorrento Valley, California, May 14, 2012
Maddie meets Betsy, the founder of Petfinder.com. Maddie was a Petfinder rescue herself.

Encinitas, California, May 14, 2012

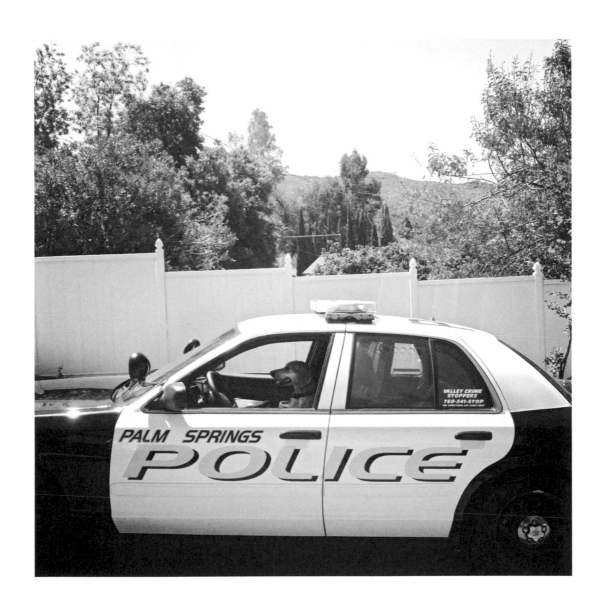

Palm Springs, **California**, May 16, 2012

Riding along with a cop was such a good day. It was a blessing to be invited to come along.
I loved how refreshing it was to see the world from a cop's perspective. How they can show
grace. And they let Maddie drive.

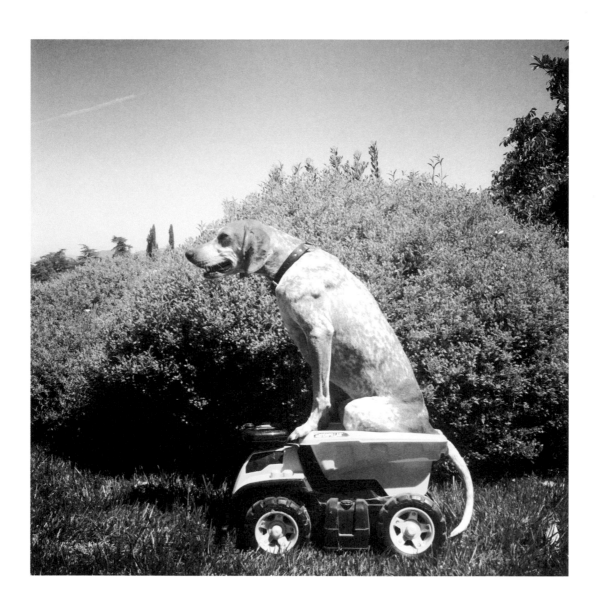

San Bernadino, California, May 17, 2012

Los Angeles, California, May 19, 2012

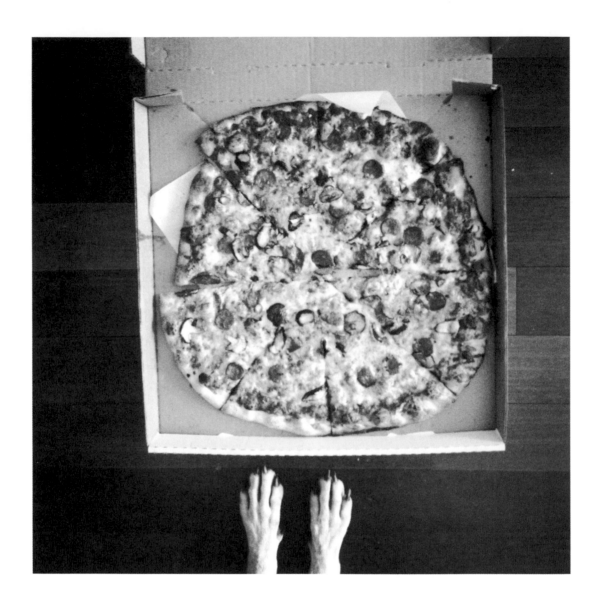

Los Angeles, California, May 19, 2012

If I could pick one food to eat for the rest of my life it would be pizza. Especially if I could always change the toppings. I'm pretty sure Maddie agrees. We actually didn't eat much pie on the road. Most places it's hard to get just a slice or two. But when we were in Los Angeles, we made fast friends and shared a large.

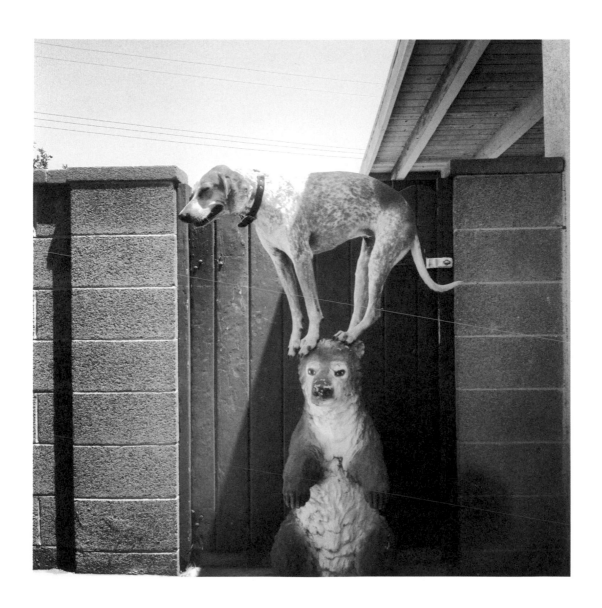

Anaheim, California, May 20, 2012

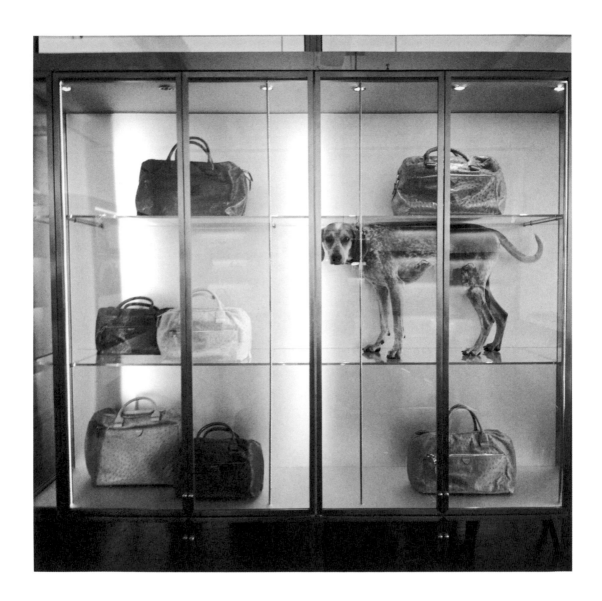

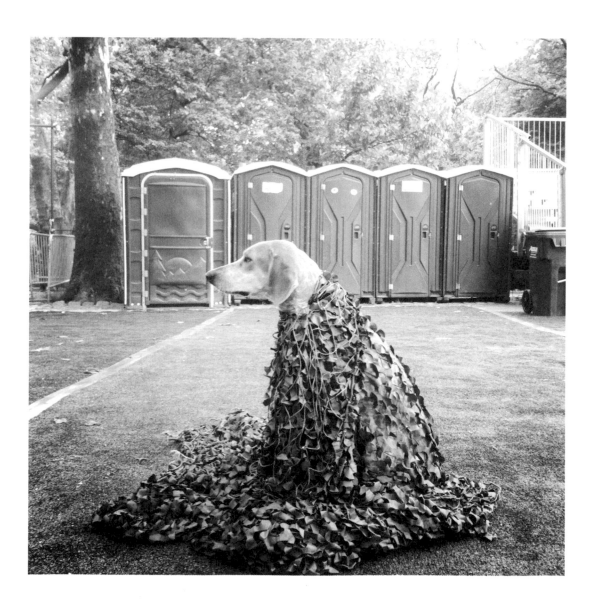

New York, New York, May 25, 2012

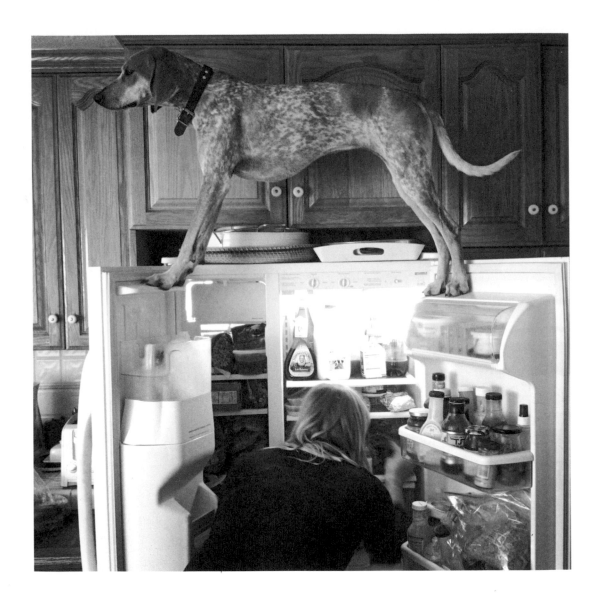

Saratoga, **California**, May 28, 2012

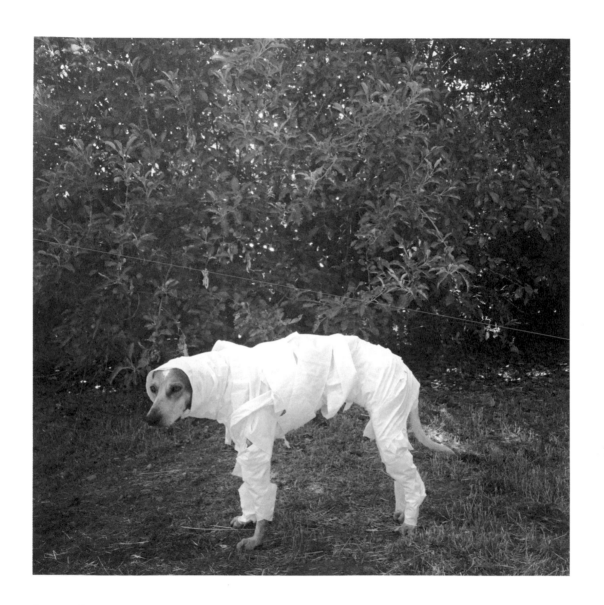

Saratoga, California, May 29, 2012

It's tough to pinpoint when or why ideas for images would pop in my mind. This one is somewhere between toilet paper commercials and mummy movies. But this is Maddie at her best. Being so patient. She kindly stood still and let me wrap her up. Minutes later she was transformed into a toilet paper mummy.

147

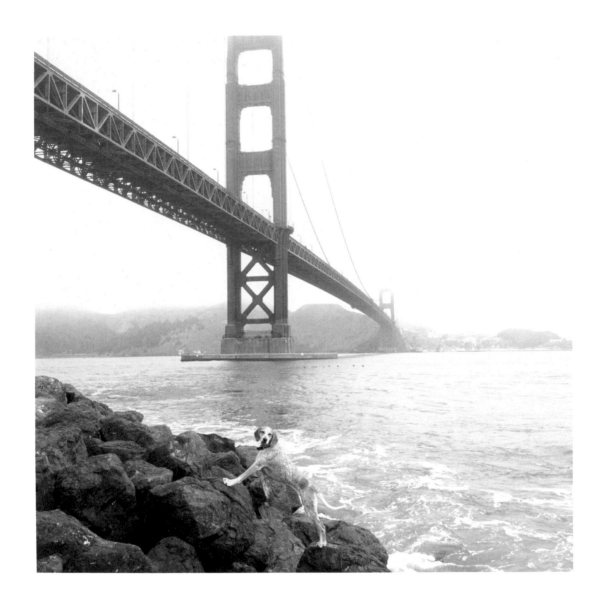

San Francisco, California, May 30, 2012

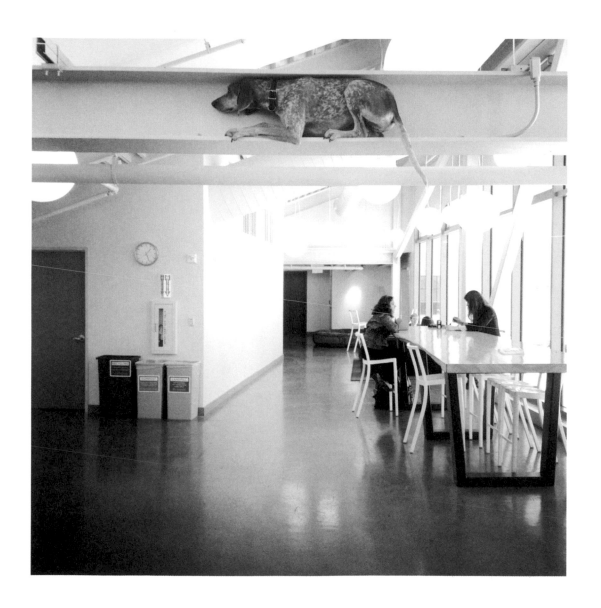

San Francisco, California, May 31, 2012

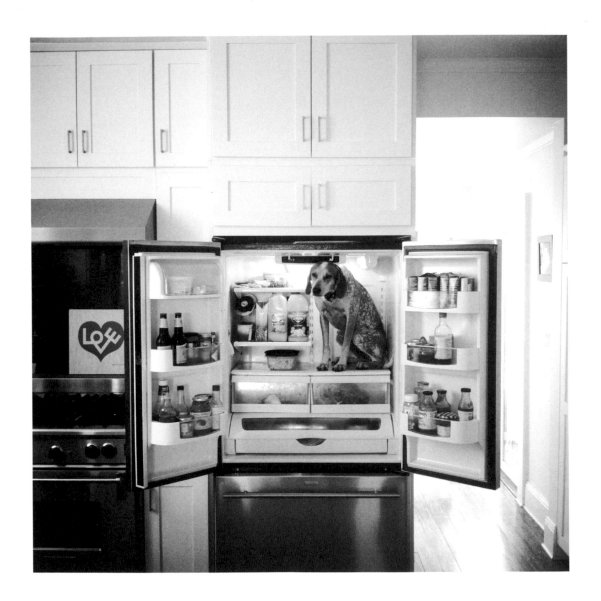

San Francisco, California, August 10, 2012

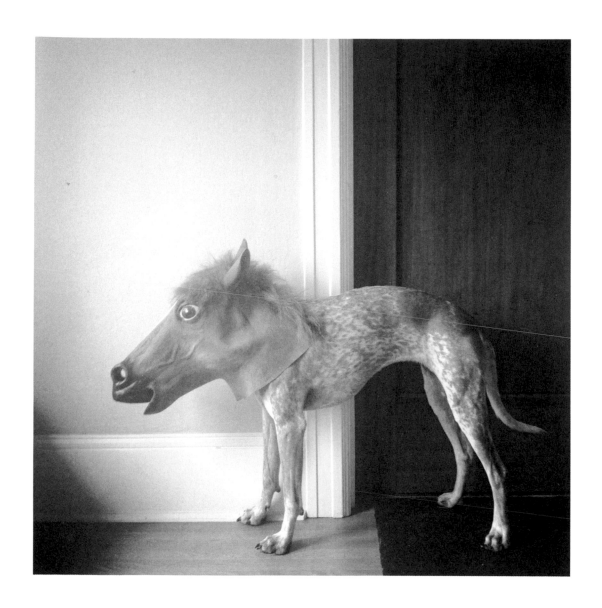

Portland, Oregon, June 1, 2012

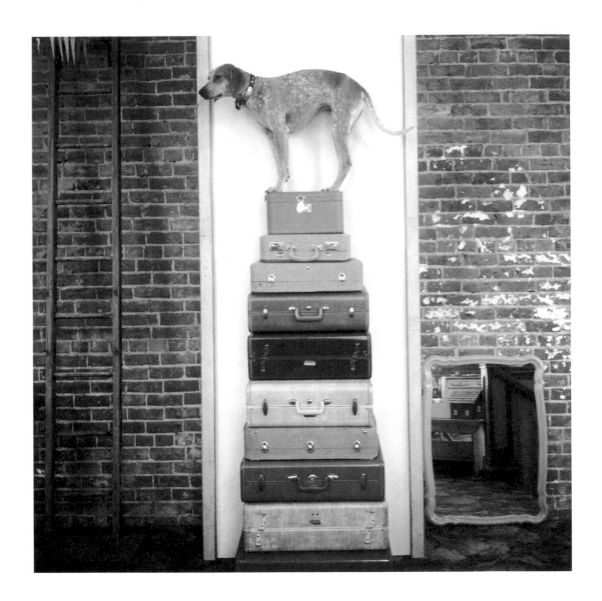

Baker City, **Oregon**, June 6, 2012

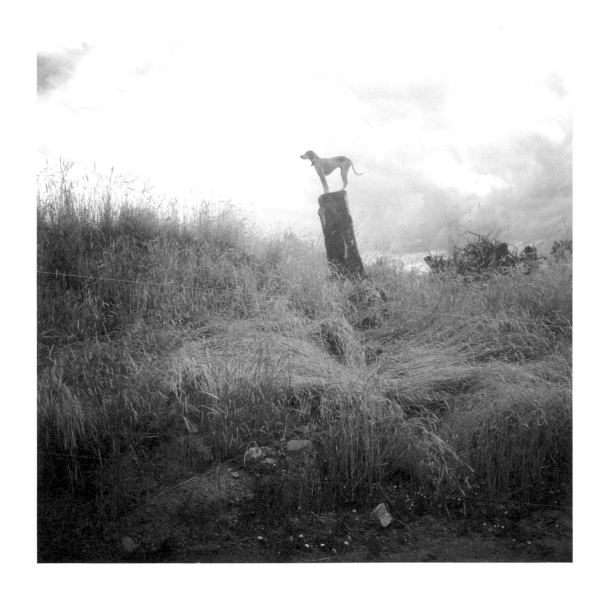

Boise, **Idaho**, June 9, 2012

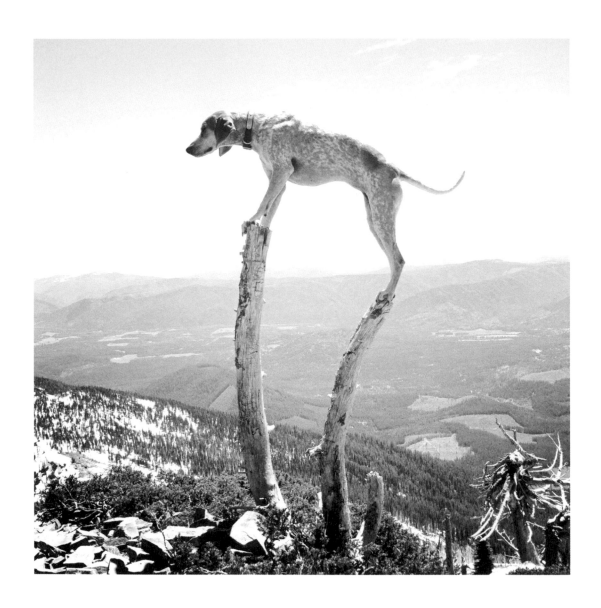

Kaniksu National Forest, Idaho, June 15, 2012

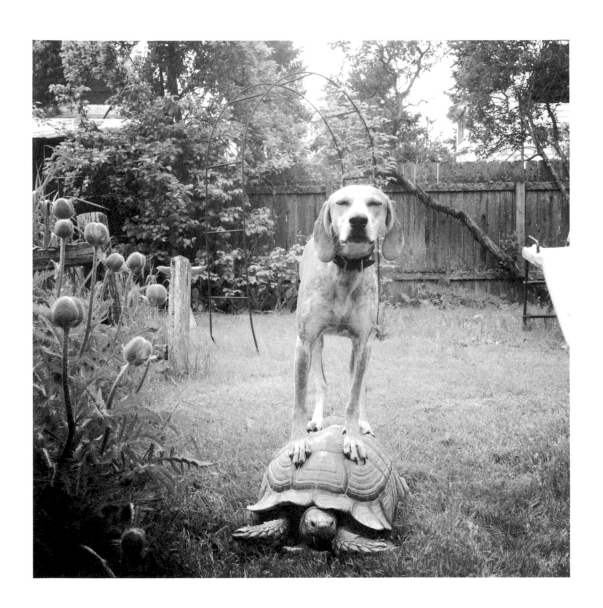

Sandpoint, **Idaho**, June 16, 2012

I never thought I'd see a tortoise hanging out in the backyard when I looked over that fence. This country is full of amazing folks. If you just knock on their door you can meet 'em. Good things happen when you ask if your dog can stand on a tortoise.

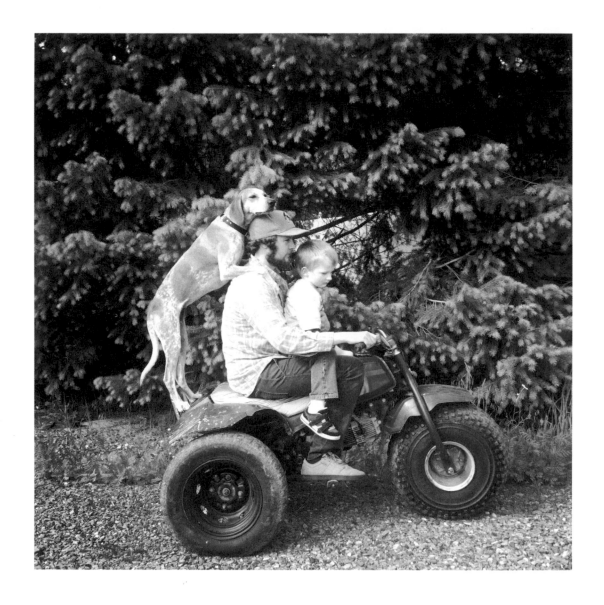

Sagle, Idaho, June 17, 2012

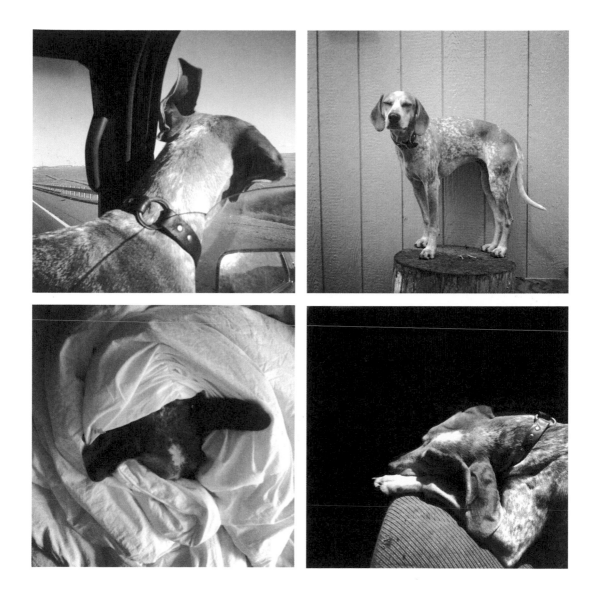

New Plymouth, Idaho

Sandpoint, Idaho

New York, New York

Boise, Idaho

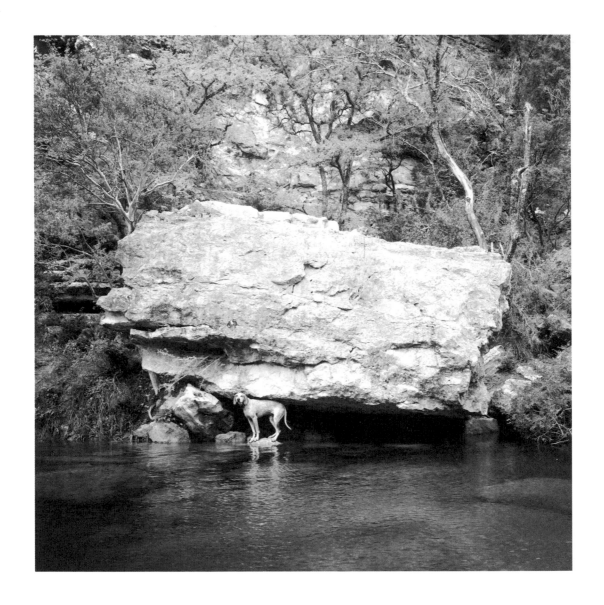

Austin, **Texas**, March 16, 2012

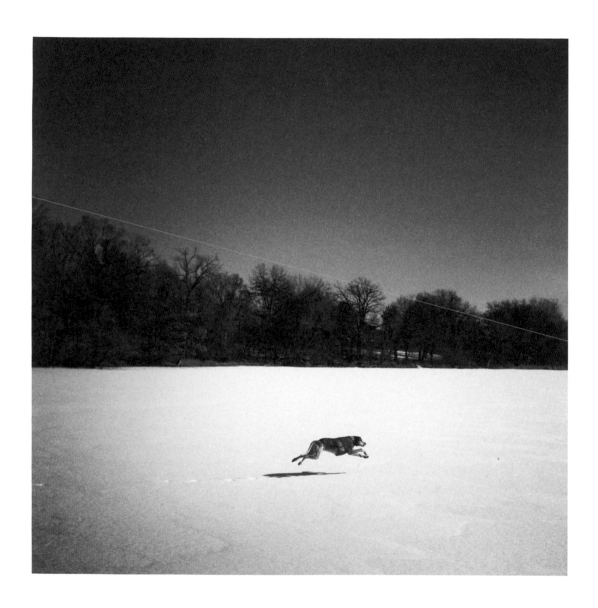

Inver Grove Heights, **Minnesota**, February 27, 2012

Copyright © 2013 by Theron Humphrey.
Page 4 photo copyright © 2012 Cory Staudacher.
Page 8–9 and endpaper Illustrations by Leslie A. Wood.
All rights reserved. No part of this book may be reproduced in any form without written
permission from the publisher.

Library of Congress Cataloging-in-Publication Data

Humphrey, Theron.
 Maddie on things : a super serious project about dogs and physics / by Theron Humphrey.
 pages cm
 ISBN 978-1-4521-1556-6 (alkaline paper)
1. Hounds--United States--Pictorial works. 2. Dogs--United States--Pictorial works.
3. Humphrey, Theron--Travel--United States--Pictorial works 4. Photography of animals--
United States. I. Title.

 SF429.H6H86 2013
 636.753--dc23

 2012044433

Manufactured in China

MIX
Paper from
responsible sources
FSC® C008047
FSC
www.fsc.org

Designed by Neil Egan

10 9 8 7 6 5

Chronicle Books LLC
680 Second Street
San Francisco, California 94107
www.chroniclebooks.com